BASEBALL
IN
LONG BEACH

BASEBALL
IN
LONG BEACH

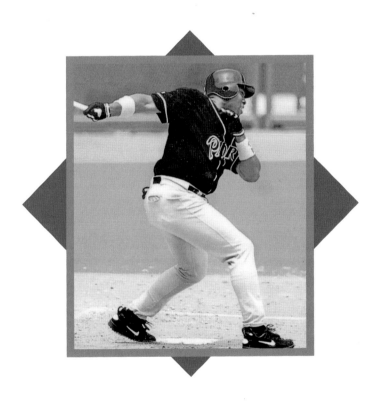

Tom Meigs

ARCADIA
PUBLISHING

Published by Arcadia Publishing
Charleston SC, Chicago IL, Portsmouth NH, San Francisco CA

Printed in the United States of America

Library of Congress Catalog Card Number: 2007941841

For all general information contact Arcadia Publishing at:
Telephone 843-853-2070
Fax 843-853-0044
E-mail sales@arcadiapublishing.com
For customer service and orders:
Toll-Free 1-888-313-2665

Visit us on the Internet at www.arcadiapublishing.com

To the many baseball heroes included in these pages who fought wars and played for the joy of it, and to my family, who brought me both to Long Beach and to baseball.

CONTENTS

ACKNOWLEDGMENTS

There are many pieces of hidden, forgotten, amusing, and largely unknown lore surrounding baseball in Long Beach. This project attempts to bring together as much of the visual historical foundations of Long Beach baseball as possible, while at no time claiming to be an exhaustive representation.

This book would have been impossible without the enthusiastic and selfless support of so many who generously donated their time, recollections, and personal photographs. It was my privilege to spend some time with each of them and to hear their stories.

I would like to personally thank Chuck Stevens, Dick Beverage, Tom Patterson, Artie Boyd, Harry Minor, John Herbold, Joe Reed, Gene "Skip" Rowland, Jack Caplinger, Jack Neuman, and all of the Long Beach Old Timers, each of whom went the extra mile in support of this book by providing photographs and historical context.

A special thank you to The Topps Company, Inc., for permission to reproduce selected images, and Jasper Nutter for his excellent photographs. Thanks also go to Darrell Evans, Beans Reardon, the late Charlie Williams, Frank Followel, Dick Rountree, Don Lang (who played for the 1938 Cincinnati Reds and the 1948 St. Louis Cardinals—no existing photograph or card of him could be found), the Long Beach Library research staff, photographer Matt Brown, and sportswriters Frank Blair, Hank Hollingsworth, Al Larson, and Bob Keisser. I would also like to thank my editor at Arcadia Publishing, Jerry Roberts, for his patience and skillful guidance at every turn. Thanks also to Rob Kangas for his keen editorial abilities.

FOREWORD

Thinking about the many years I have been part of the Long Beach baseball community brings back the fondest of memories. I consider Long Beach to be the greatest city in our nation in the development of baseball players and coaches, and we all felt it was a privilege to have grown up here. I would like to name a few of my baseball friends and teachers who meant so much to me over the years:

Bob Hughes
Mike Romero
Charlie Brown
Bill Feistner
Bill and Ed Chittick
Jack and Bobby Salveson
the Gabler Brothers
the Lang Brothers
Jack Rothrock
Eddie Bockman
Lee Stine
Walt Carson
Geo Caster
Jack Graham
Bob Lemon
Vern Stephens
Bob Sturgeon
Wilbur Wise
"Red" Ruffing
Harry Danning
Max West
Nanny Fernandez
Ed Nulty
Art Lilly
John Kerr
Bob Boken
Bob and Irish Muesel

I know I speak for all of those mentioned when I thank Tom Meigs for his work in the perpetuation of baseball history in Long Beach.

—Chuck Stevens
November 2007

INTRODUCTION

The 1910 Long Beach Clothiers and the 1913 Long Beach Beachcombers of the Southern California Trolley League adjusted their ball class rankings by census figures and rambled around playing circuit games wherever a trolley could take them. The Beachcombers' 1913 record stands at 43 wins and 46 losses despite having a management team that included Bull Durham.

Passing decades soon brought exhibition games featuring players like Babe Ruth, Lou Gehrig, Grover Cleveland Alexander, Joe DiMaggio, Bob Feller, and Satchel Paige. In time, an entire cascade of homegrown baseball talent, including MLB Hall of Fame players Bob Lemon and Tony Gwynn, would insure that Long Beach has definitively contributed to baseball history.

On March 25, 1918, Grover Cleveland Alexander took the mound at old Poly High field as Alexander's Cubs went on to beat Long Beach Polytechnic High School by a score of 4–1. Alexander must have enjoyed the locale because he ended up living in Long Beach for a period. Bill Feistner, one of the most pioneering and entrepreneurial spirits in baseball, built the first truly accommodating baseball park in 1922 at Redondo Avenue and Stearns Street in the shadows of oil-rich Signal Hill.

Shell Park was Feistner's creation, and when ballplayers were not on the ball field, they could often be found working the oil fields. Before construction on Shell Park was completed, 50 or more Ford Model Ts could be seen parked along the foul line doing their part to help define the fair from the foul. The 1925 world champion Pittsburgh Pirates created plenty of excitement when they visited Shell Park for a game in 1926, beating the home team, the Shell Oilers, by a score of 5-3.

In 1924, Recreation Park opened for the public, creating a training ground for spectacular talent in the years to come. The Chicago Cubs, who trained on nearby Catalina Island, played the Pacific Coast League's Los Angeles Angels team in the dedication game for "Rec Park." The consistently good, year-round weather, and access to four softball playing fields combined to create the perfect atmosphere to nurture both softball and baseball talent.

Strangely, two days of continuous rain—quite unusual weather in Long Beach—caused the cancellation of a game featuring Babe Ruth and Lou Gehrig on Halloween Eve of 1927. Yet both returned to play a year later.

The era of the 1930s produced several active semiprofessional teams. At the same time, the American Legion sponsored teams like the Ell Bees (pronounced "LBs," as in Long Beach). The war years from 1942 to 1945 saw an entire lineup card of baseball talent stationed in Long Beach and nearby Santa Ana.

During the late 1940s and the 1950s, the Long Beach Rockets were active. Tremendous contributions made by players and coaches alike allowed teams to play for several decades at Long Beach City College and Long Beach State University. The 1990s saw a veritable re-emergence of independent teams as the Long Beach Barracuda and Long Beach Riptide were established. The 2000s saw the tradition continue with the Long Beach Armada beginning play at Blair Field.

EARLY YEARS

The largest personality in early Long Beach baseball was promoter William "Bill" W. Feistner, who created and managed the original Shell Oilers team and proceeded to promote local baseball for the next 50 years. In 1922, the Shell Oil Company agreed to build a ballpark for the Oilers at the corner of Stearns Street and Redondo Avenue.

Before radio broadcasts of World Series games were available, the *Long Beach Press* established a magnetic scoring tower constructed on East Broadway Street and Lime Avenue. The game play board on the scoring tower featured a baseball diamond with moving parts operated manually by men working in the tower behind the board's surface. Plays would come into the tower via telegraph, and workers would re-create each play by moving figures, operating the bat swing, and adjusting names. Peanut vendors provided snacks for those seated on wood planks and boxes in view of the scoring tower.

An August 1922 doubleheader at Shell Park featured a jazz performance by Standard Oil's 35-piece orchestra. The Shell Oilers won both games, 4-3 and 5-4.

The Shell Baseball Park was officially dedicated on August 19, 1923, with a 4-1 victory over the Santa Fe Springs team from Union Oil. Connie Mack brought the 1929 and 1930 world champion Philadelphia Athletics to Shell Park to play Feistner's Oilers in 1930. Three years later, the Hollywood Stars of the Pacific Coast League held their spring training camp at Shell Park when the Long Beach earthquake of March 10, 1933, struck with devastating results. At the time, the team was staying at the Breakers Hotel along Ocean Boulevard.

Several professional clubs wanted to play in Long Beach at that time, including the Chicago Cubs (training on nearby Catalina Island) and the Pacific Coast League's Los Angeles Angels.

With the increasing demand for an improved ballpark, Long Beach officials began making plans in late 1923 for a Recreation Park baseball site, including a grandstand that would seat close to 1,000 spectators.

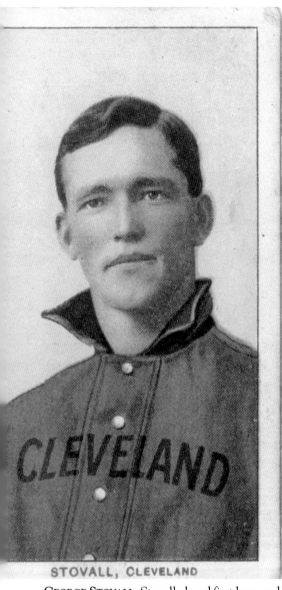

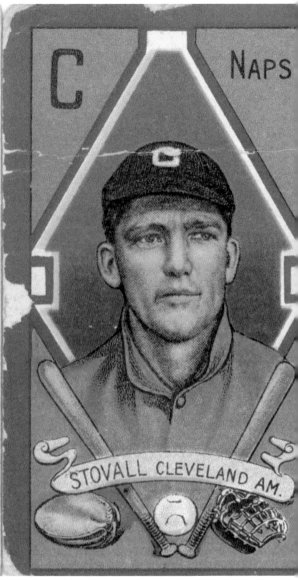

STOVALL, CLEVELAND

GEORGE STOVALL. Stovall played first base and infield from 1904 to 1911 with the Cleveland Naps of the American League and in 1912 and 1913 with the St. Louis Browns. He spent the 1914 and 1915 seasons with the Kansas City Packers of the Federal League. As a big-league veteran living on Cherry Avenue, he played early baseball in Long Beach and aspired to invest in a ballpark for the city in 1909.

BARNSTORMING. This 1920s poster advertises an exhibition game run by baseball promoters like William "Bill" Feistner at Shell Field. This poster style typifies the kind in circulation during the rained-out appearance of Babe Ruth and Lou Gehrig at Shell Field on Halloween Eve of 1927.

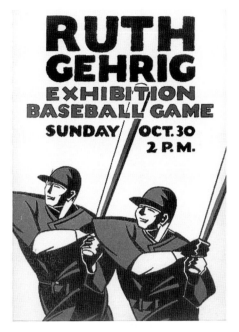

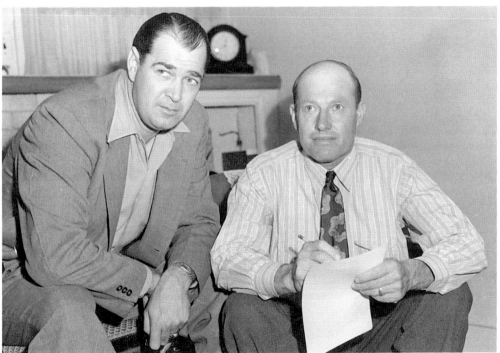

WILLIAM "BILL" FEISTNER. An early pioneer and entrepreneur in baseball promotion for Long Beach, Feistner was the founder and manager of the Shell Oilers. He staged exhibition games and barnstorming tours, including appearances by Lou Gehrig, Babe Ruth, and Satchel Paige. Pictured on the left is Bobo Newsom. Newsom made his major-league pitching debut for the Brooklyn Dodgers on September 11, 1929.

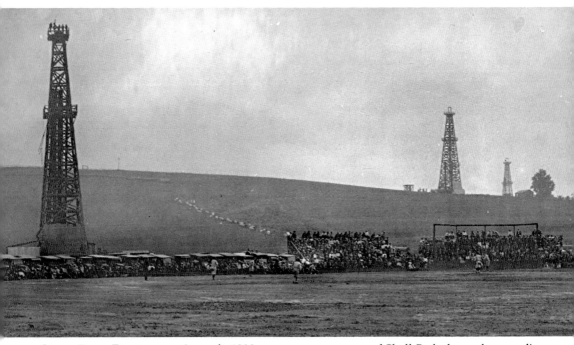

SHELL FIELD PANORAMA. An early 1920s panorama sequence of Shell Park shows the crowd's Ford Model Ts that were used to determine and enforce the foul lines. Oil derricks on the Shell

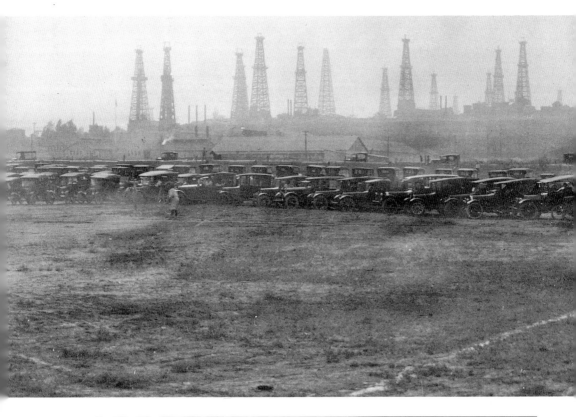

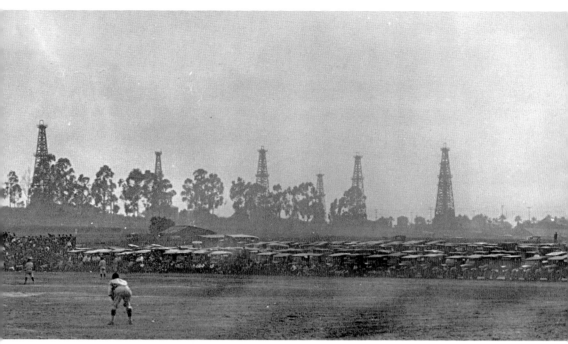

property can be seen prominently in the background. An early version of the park's grandstand, although not yet fully constructed, is visible.

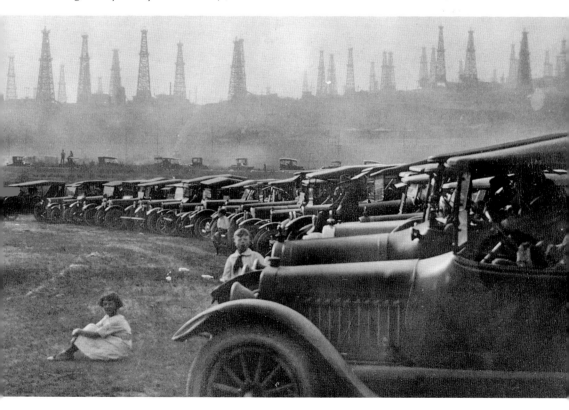

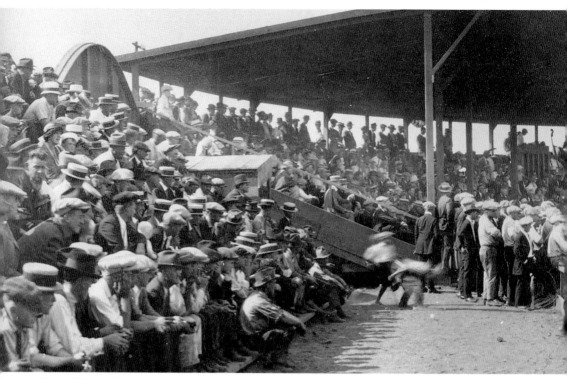

SHELL FIELD CROWD. This image of Shell Field is complete with a dugout and grandstand shade for an August 26, 1923, game between Shell Oil and Union Oil. The modern-day location is on

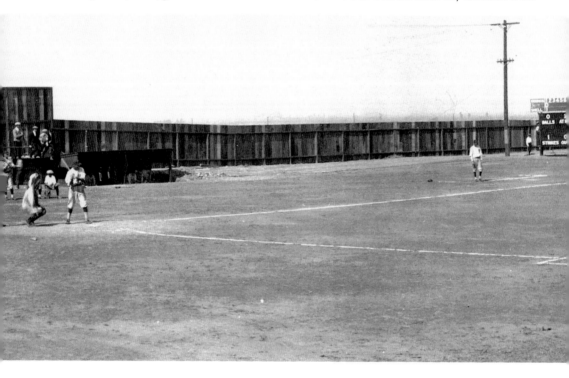

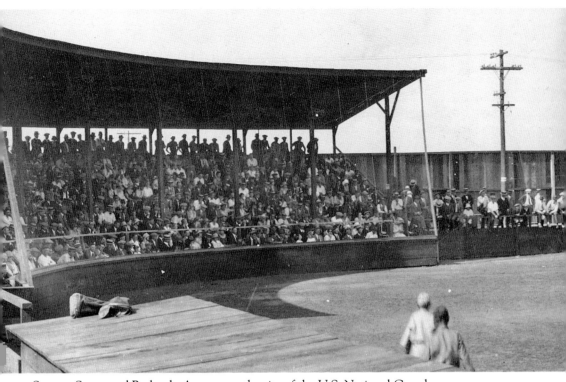

Stearns Street and Redondo Avenue on the site of the U.S. National Guard armory.

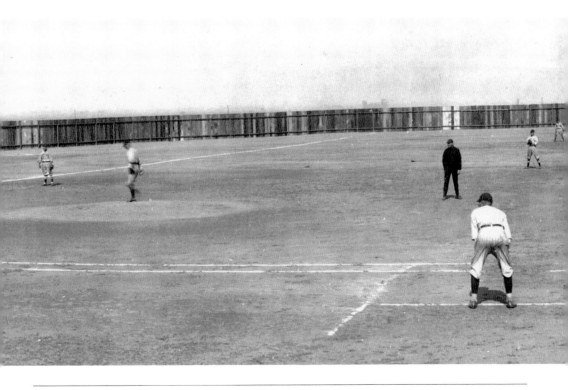

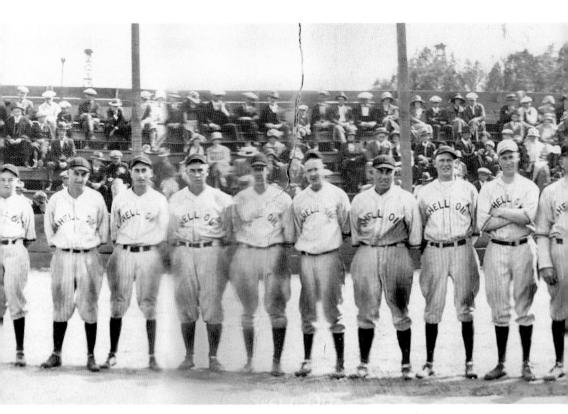

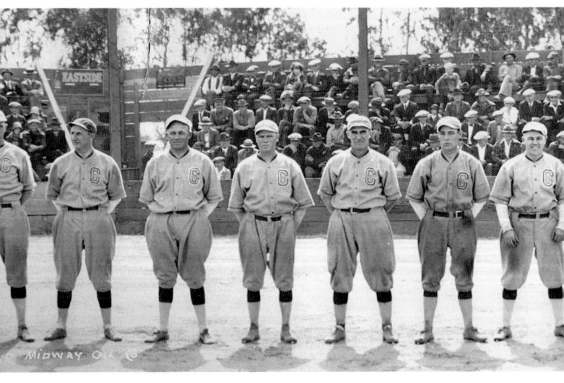

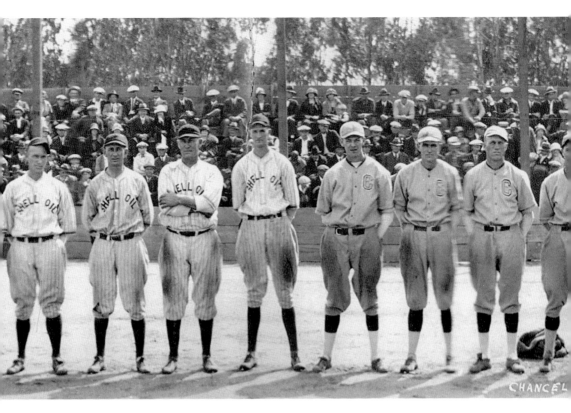

SHELL VERSUS MIDWAY.
Here are the complete team lineups at Shell Field for Shell Oil (above left) versus Chancelor Canfield/Midway Oil (above right and below).

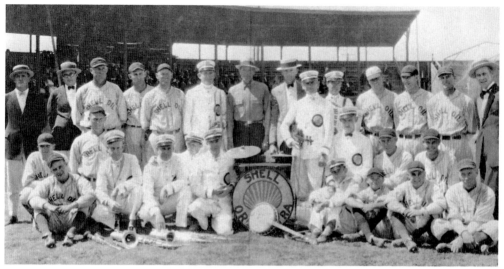

STRIKE UP THE BAND. Shell Oilers players from the 1920s included members of the Shell Orchestra, a band that often played on game days. The Shell Field bleachers are visible in the background.

SCHOOL YARD BALL. A local game is under way at a Long Beach school yard in the 1920s. The fence along the right-field foul line featured a sign posting that read, "Sunday Use Forbidden."

EARLY YEARS

Original Bash Brothers. Brothers Lloyd and Paul Waner combined for 5,611 hits, holding the career record for total hits by brothers. Almost every one was hit for the Pittsburgh Pirates. Paul played at Shell Field on March 23, 1926, against the Oilers as a member of the 1926 World Champion Pirates.

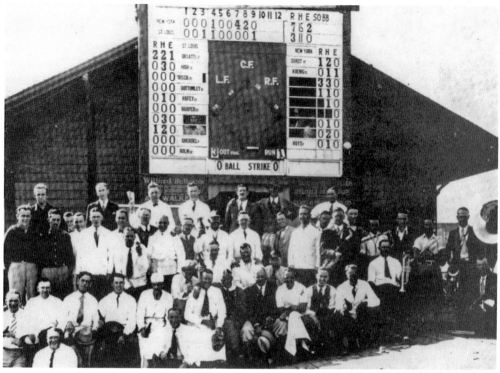

KEEPING SCORE. The *Long Beach Press* sponsored a World Series scoreboard on East Broadway Street before games were available for broadcast on the radio. The mechanical scoreboard was operated manually using information from an on-site telegraph and featured the swing of a bat, bells, base-runner positions, and other scoring information. (Courtesy of the Long Beach Collection, Long Beach Public Library.)

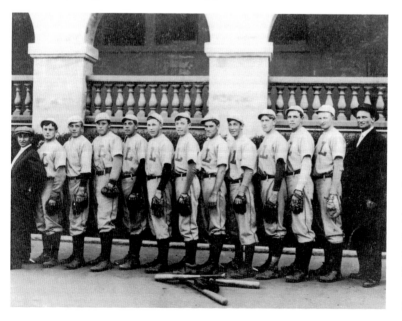

POLY HIGH TEAM, 1910. Long Beach Polytechnic High School was established in 1895 as the first high school in the city. This official team photograph features the 1910 baseball team lineup.

BABE PAYS THE FINE. A 1920s-era photograph shows Babe Ruth handing a cash fine to a Long Beach police officer. Local legend supports the idea that Ruth was given a modest fine for asking a local boy to dance for a moment in exchange for an autograph in supposed violation of child labor law. This cannot be known for certain. (Courtesy of the Long Beach Collection, Long Beach Public Library.)

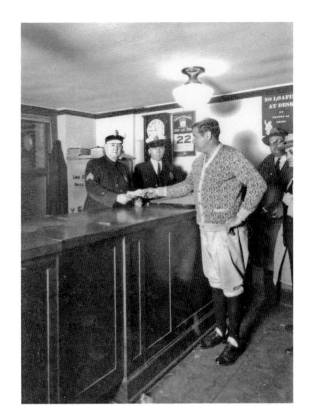

GEORGE "PEACHES" GRAHAM. Graham, seen here in a Shell Oilers uniform after his major-league playing days, was the father of Jack Graham. He was born March 23, 1877, in Aledo, Illinois, and died July 25, 1939, in Long Beach. He was active at the major-league level from 1902 until 1912, playing for the Cleveland Bronchos, Chicago Cubs, Boston Doves, Boston Rustlers, and Philadelphia Phillies.

JOHN KERR. An early 1920s photograph of Kerr as a member of the Shell Oilers was taken at Shell Field. Kerr hit .273 for the 1924 Detroit Tigers, managed by Ty Cobb, and continued his career playing three seasons for the Chicago White Sox (1929–1931) and three seasons for the Washington Senators (1932–1934).

JOHNNY RAWLINGS. A member of the 1925 World Champion Pittsburgh Pirates, Rawlings and the Pirates played at Shell Field against the Oilers on March 23, 1926. This game was the first appearance by a world-champion team in Southern California since the 1906 Chicago White Sox played in Los Angeles in 1907.

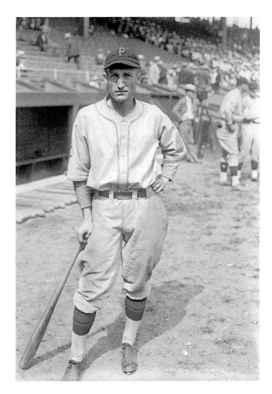

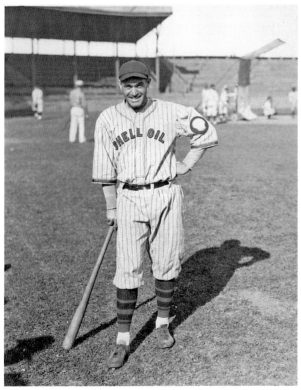

BATTING PRACTICE. A Shell Oilers player takes a break with the Shell Field grandstand visible in the background. Although exact player names are not known, the 1925 Shell Oilers included Bill Sweeney (center field), Doc Crandall (second base), Billy Orr (third base), Jim Blakesly (right field), Frank Metz (first base), Snyder (left field), Eddie Kenna (catcher), Johnny Butler (third base), and Ivy Griffin (shortstop). Pitchers included Ferdie Schupp, Hi Bell, and Pug Cavet. Bell and Cavet had been recently acquired from the White Kings.

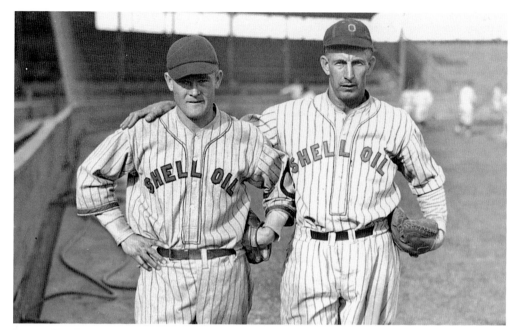

SHELL OIL DUO. Two 1920s-era Shell Oilers players are seen at Shell Field. Beginning as the Shell Company of California in 1915 in Wilmington, Shell Oil has maintained a presence in the Long Beach area for nearly a century.

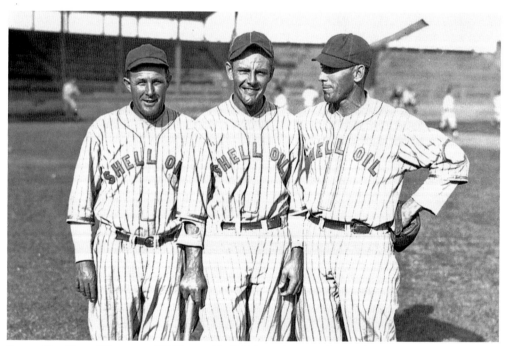

SHELL OIL TRIO. This trio of 1920s-era Shell Oilers players is featured in a group photograph at Shell Field, which was located at the base of Signal Hill. Signal Hill was often called "Porcupine Hill" because of the oil derricks that covered it.

FIELDER'S STANCE. A Shell Oil player takes fielding practice. Often baseball was the main source of recreation for the oil-field workers.

PRACTICE SWINGS. A member of the Shell Oilers takes a few practice swings on the grass at Shell Field.

SPLIT FINGER. A Shell Oil player demonstrates a throw release point.

GOT IT! A Shell Oil player is depicted ready to catch a pop fly.

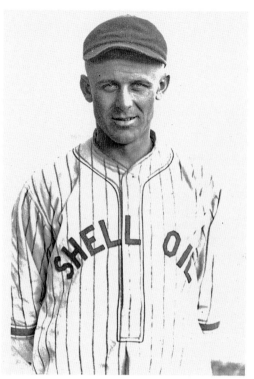

FIXED GAZE. A Shell Oil player with a calm and determined view shows the Oilers' uniform details.

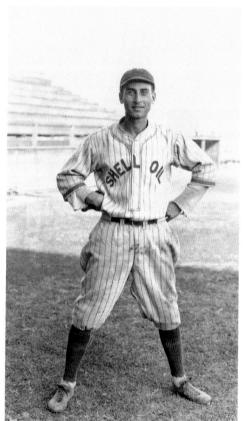

GLAD TO PLAY. Ready for the game, a Shell Oilers player, complete with undershirt in the usually warm weather, holds a pose.

DOUBLE DUTY. A Shell Oilers player is shown with a glove in his pocket and a bat in his hands.

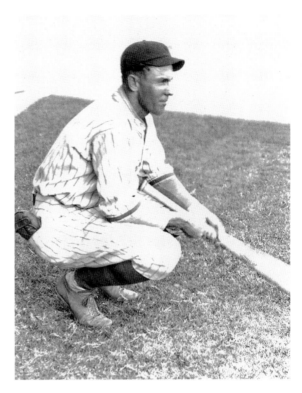

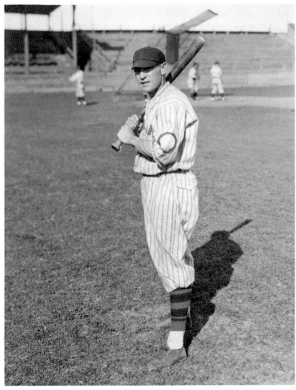

RELAXED STANCE. A member of the Shell Oilers relaxes his stance while batting practice continues in the background.

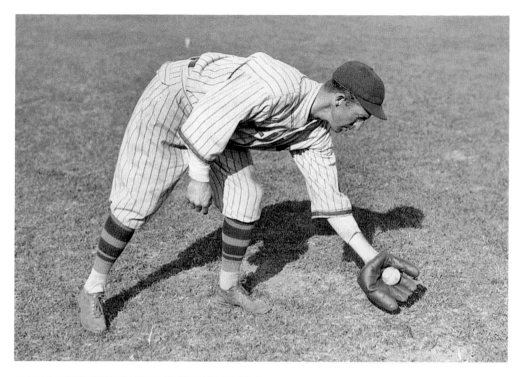

FIELDING POSE. A Shell Oil player poses in a fielding position on the grass.

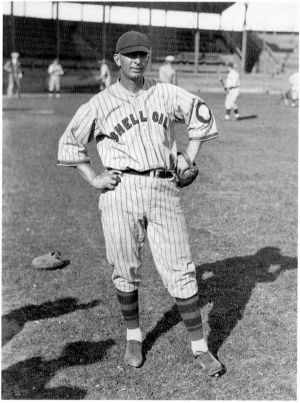

QUICK BREAK. A Shell Oil player takes a moment to pose for the camera while batting practice continues in the background.

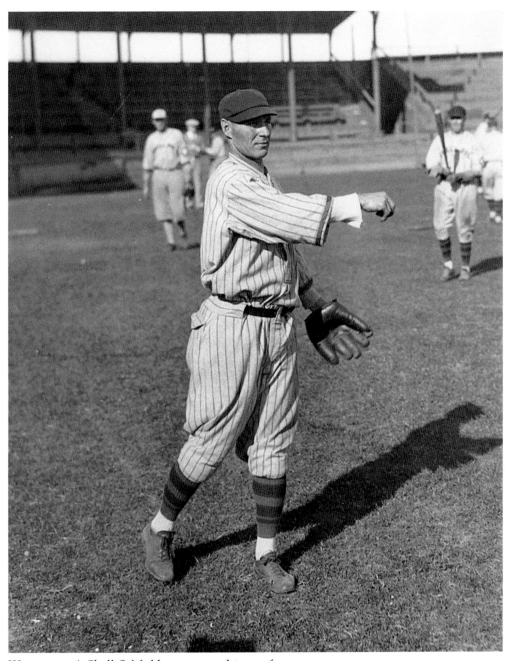

Warm-ups. A Shell Oil fielder warms up his arm for a game.

OTHER UNIFORM. A Shell player displays the Shell logo version of the team's uniform without "Shell Oil" printed across the front of the jersey.

READY FOR ACTION. A Shell
Oil player readies his stance.

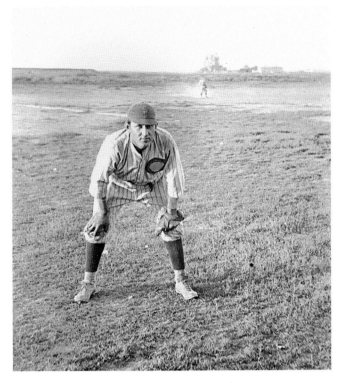

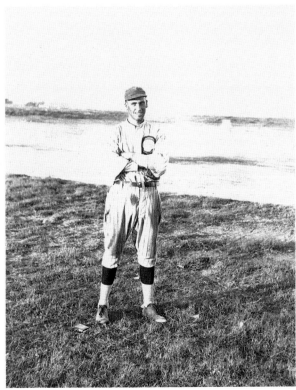

CASUAL MOMENT. Without a glove,
this image shows a candid casual
moment for a Shell Oil player.

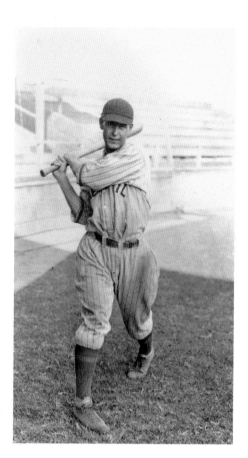

FOLLOW THROUGH. A Shell Oil player completes the follow through on his swing.

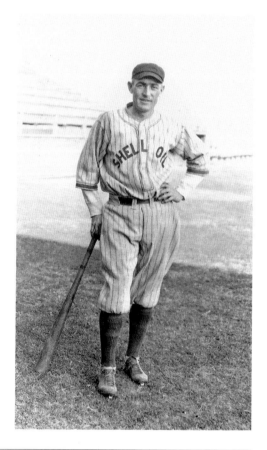

COOL CONFIDENCE. A Shell player wearing the single upper toe–style cleat poses in front of the grandstand at Shell Field.

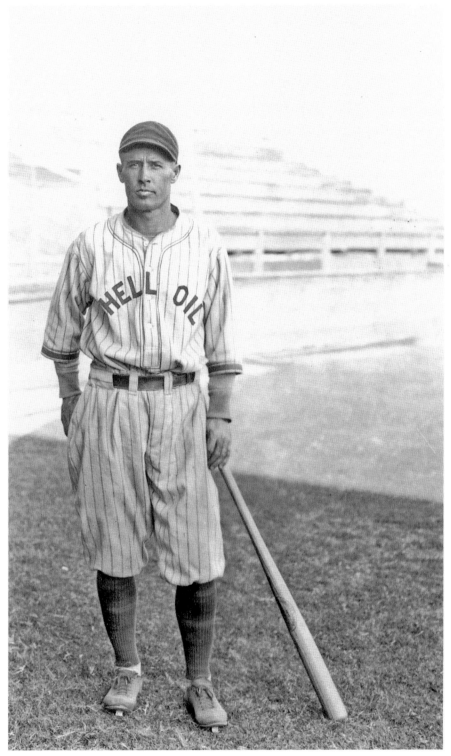

ANOTHER VIEW. A Shell Oilers player with a concerned expression poses before the grandstand.

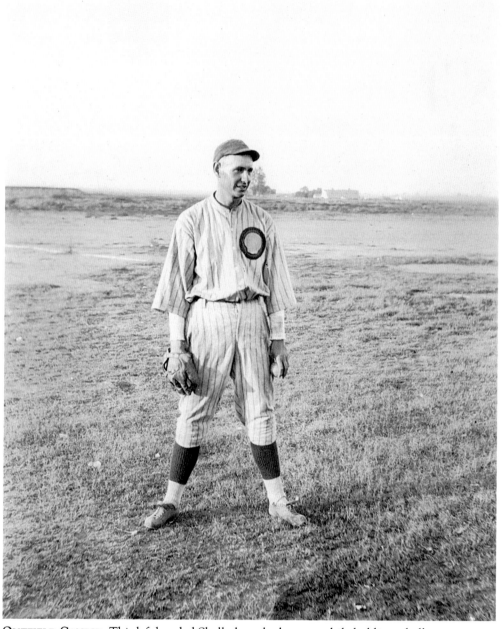

OUTFIELD CANDID. This left-handed Shell player looks away while holding a ball.

THE FOUNDATIONS

On March 14, 1924, Chicago Cubs owner William Wrigley and his team took a steamboat from Catalina Island to the municipal wharf. The Cubs and the Los Angeles Angels were scheduled to play a dedication game at Recreation Park that same day. Long Beach mayor Charles A. Buffum threw out the first ball.

With the establishment of Recreation Park in 1924, Long Beach baseball entered a new era of possibility and potential. In fact, the four arranged ball fields of Recreation Park quickly became known as a mecca for ballplayers. Hundreds of softball teams with sponsors from across the city made use of these fields, continuing to play under the lights well into the evening. The infields featured no grass because of the heavy use of softball teams, making for a less-than-perfect setting for baseball, but players made due. Softball was the universal entry point to baseball for a wide range of players and the perfect outlet for a summertime kid in the city.

Coaches like Bob Hughes, Mike Romero, Bill Feistner, and John Herbold became fathers away from home for many young players. They schooled each player in the game's fundamentals, helping them practice the mechanics that routinely win or lose games.

Softball was played on the Pike, the waterfront entertainment section of the city, with Lou Novikoff as a star attraction. Joe Rodgers developed the Long Beach Nitehawks softball team and served as owner, manager, and shortstop, guiding them to seven International Softball Congress championships. American Legion–sponsored baseball gained momentum and used Recreation Park as its home field.

Bill Feistner continued to promote baseball at several venues, including Recreation Park and Wrigley Field in Los Angeles. He owned and operated the Long Beach Rockets, a semiprofessional club active for several decades. Feistner's exhibition game offerings featured Bob Feller, Satchel Paige, and Cool Papa Bell in the late 1930s and 1940s. It is important to note that even when Major League Baseball had refused to integrate, professional players in Long Beach commonly shared dressing rooms without any issue.

Everybody involved in baseball in the years documented here used Recreation Park/Blair Field, including high school teams like Woodrow Wilson and Long Beach Polytechnic, American Legion teams, college teams like Long Beach State University, Connie Mack, and many semiprofessional and professional teams. Beginning in the 1920s, Recreation Park was one of the busiest municipal baseball parks in the United States.

On May 10, 1958, Recreation Park was rededicated as Blair Field, named after the city's prominent sportswriter Frank T. Blair.

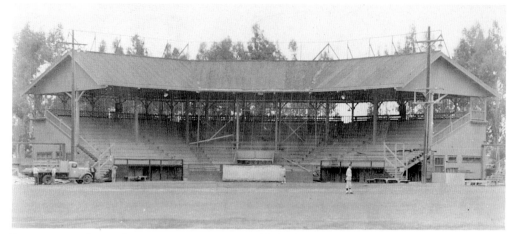

RECREATION PARK GRANDSTAND, 1939. Established in 1924, Rec Park became a mecca for ballplayers for decades to come. This park was the central training grounds for a wide range of baseball talent. The Dodgers, Los Angeles Angels, Hollywood Stars, and a variety of Feistner-promoted exhibition games featuring players like Bob Feller, Satchel Paige, and Cool Papa Bell, all played here.

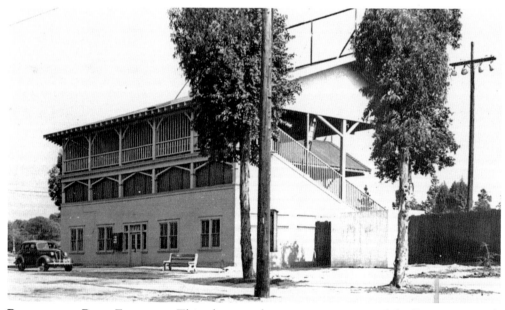

RECREATION PARK EXTERIOR. This photograph is an exterior view of the Recreation Park grandstand from the early 1940s. During World War II, players like Harry Danning (New York Giants), "Red" Ruffing (New York Yankees), Max West (Boston Braves), Nanny Fernandez (Boston Braves), and Long Beach's own Chuck Stevens (St. Louis Browns) were stationed in Long Beach. Just a few miles south, Joe DiMaggio was stationed at the Santa Ana Army Air Base. His appearances at Recreation Park were always a welcome source of excitement. Together these players raised considerable amounts of money to purchase baseball equipment for armed-forces members stationed overseas.

THE FOUNDATIONS

FEISTNER AND GOODALL. Bill Feistner works over the shoulder of a cigar-chomping George Goodall, a longtime publicist for the Los Angeles Angels. As a complete and uncompromising baseball promoter, Feistner's network featured most of the major players and teams of the day.

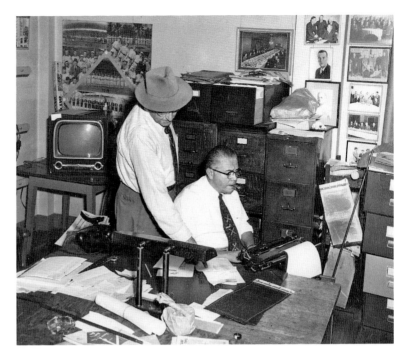

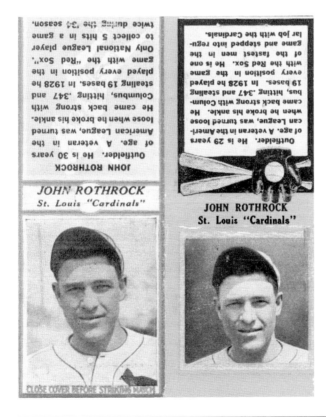

JOHN "JACK" ROTHROCK. Rothrock was the first player born and raised in the city of Long Beach to rise to the major leagues. Here he is featured on matchbook covers from the early 1930s. Rothrock played for the Boston Red Sox from 1925 until 1932, earning the American League MVP award in 1927.

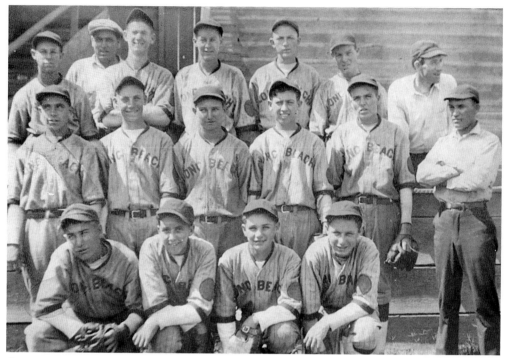

ARTHUR L. PETERSON POST NO. 27. This image is of the American Legion Junior Baseball Team and Southern California champions of 1929. Pictured from left to right are (first row) Johnie Dias (pitcher), Anthony White (pitcher), Ed Yocky (first base), and Loran Buchnam (catcher); (second row) Gene McCormick (third base), Lawrence Yocky (shortstop), Joe Blehm (right field), Bill Bennett (utility), Jack Hile (pitcher), and Mike Romero (coach); (third row) Lee Stine (infielder), "Slim" Wilson (Shell Oil representative), Bob Zuhrer (center field), Ernie Holbrook (second base), Day Hodges (catcher), Walter Carson (infielder), and Bob Hughes (trainer). Lee Stine and Walter Carson would both go on to play in the major leagues.

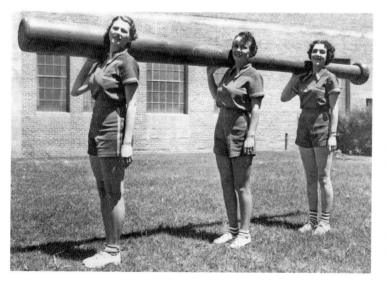

A WHOPPER. Softball players in the early 1930s near Recreation Park are holding "Whopper" the softball bat on their shoulders. Softball games ran continuously on the four fields that together formed Rec Park. (Courtesy of the Long Beach Collection, Long Beach Public Library.)

THE FOUNDATIONS

AL JOHNSON. The measure or standard of a coach for many, Johnson coached Woodrow Wilson High School's baseball team from 1936 to 1946, winning seven titles. The number of players and coaches influenced directly by Johnson's mentorship is difficult to comprehend.

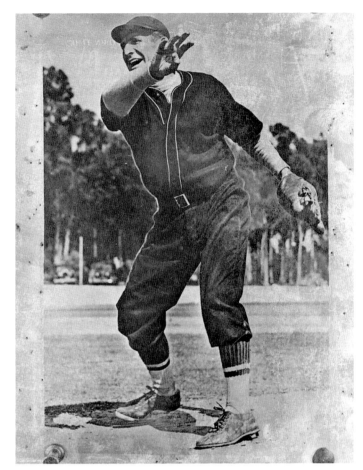

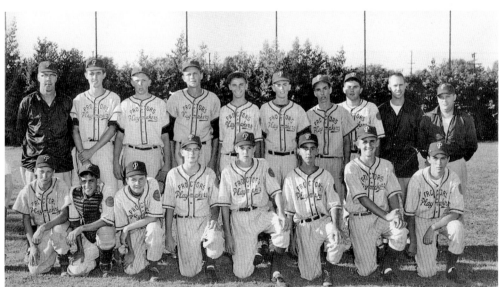

PROCTOR'S PLAYMAKERS. This was a prominent, locally sponsored team during the 1930s.

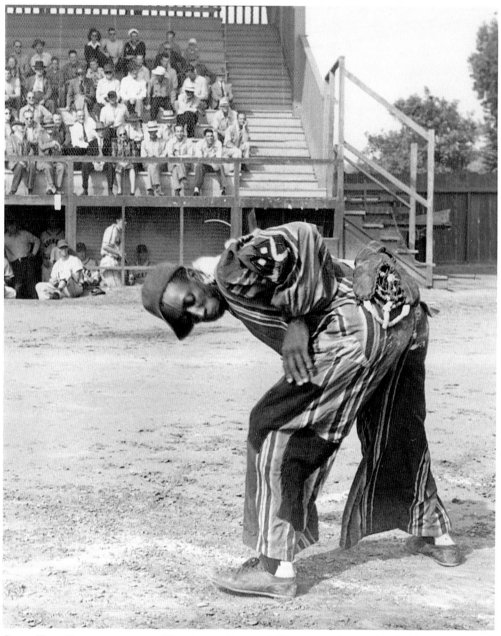

GAME-TIME ENTERTAINMENT. This image shows a 1930s-era performer for the Recreation Park crowd with part of the grandstand in the background.

THE FOUNDATIONS

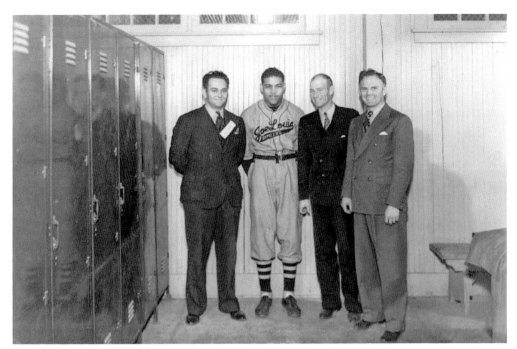

JOE LOUIS BOMBERS. An athlete of immense contribution to sporting forms in America, Louis was given a full tour of the Recreation Park facilities, including the locker rooms, in preparation for a softball game appearance on October 8, 1937. A sellout crowd was in attendance. (Courtesy of the Long Beach Collection, Long Beach Public Library.)

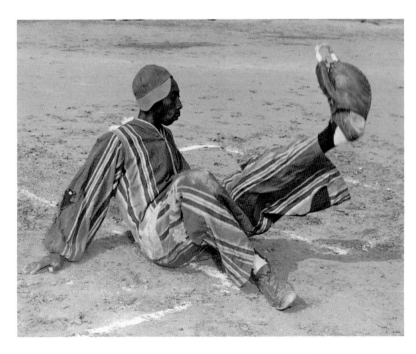

SURE-FOOTED. Games often featured amazing warm-up performances of acrobatic skill and agility that were unique to baseball. Here a performer catches pitches with a baseball glove on his foot.

GILMORE FIELD RAZING. This is an early look at the field razing being done at the inception of the construction of Gilmore Field in 1939. This field would function as the home park of the Hollywood Stars, located at 7700 Beverly Boulevard in Los Angeles. It would also play host to many exhibition games organized by Bill Feistner, drawing both players and fans from Long Beach.

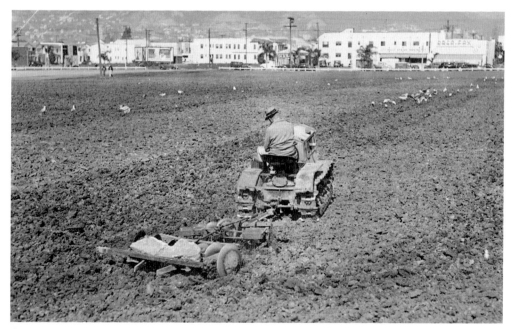

GILMORE FIELD LEVELING. A tractor works to level the ground across the site of the construction of Gilmore Field.

THE FOUNDATIONS

GILMORE FIELD SURVEY SETUP. The survey crew gathers to begin marking locations, curves, and the general layout for the construction of Gilmore Field.

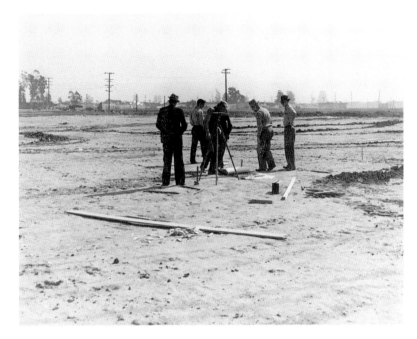

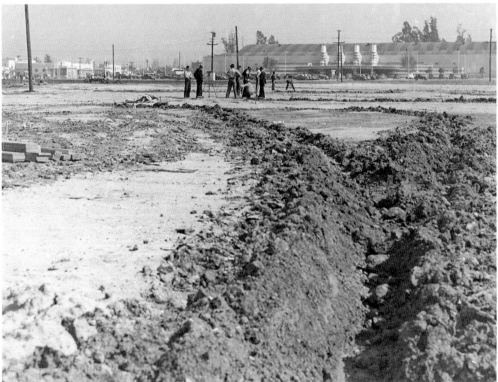

GILMORE FIELD SURVEY ACTION. A survey crew is at work, marking the construction of Gilmore Field. The trench line in clear view may represent the initial curvature of the outfield wall for the park.

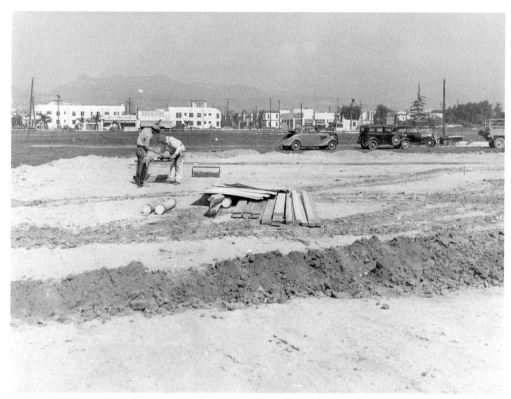

GILMORE FIELD EARLY WORK SITE. A carpentry crew begins the work-site setup for construction on Gilmore Field.

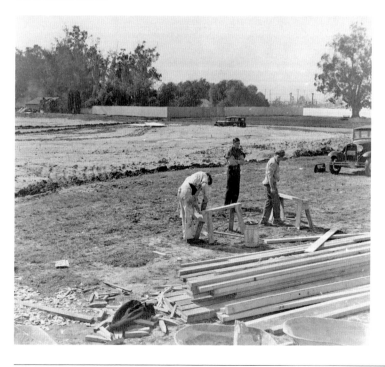

GILMORE FIELD CONSTRUCTION. Once layout and planning were complete, construction began on Gilmore Field.

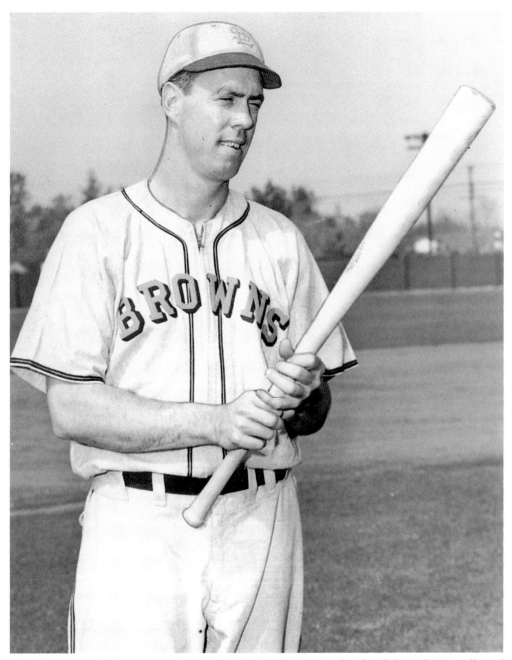

JACK GRAHAM. Graham, a member of the Woodrow Wilson High School class of 1936, collected 2,145 career hits and 422 home runs. He led the Pacific Coast League in home runs and set the San Diego Padres home run record in 1948 with 48. He continued his contributions to baseball after his professional days, becoming an instrumental influence and presence in local baseball for kids by purchasing baseball gloves and other equipment as well as offering moral support.

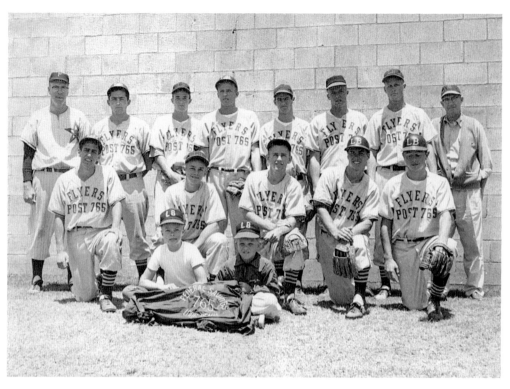

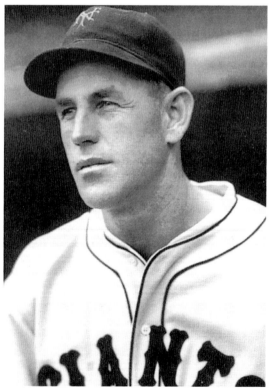

AMERICAN LEGION FLYERS POST NO. 765. An active American Legion team from the 1930s and 1940s, the Flyers from Post No. 765 were one of a number of teams using Recreation Park for baseball games.

FRANK GABLER. A pitcher for the New York Giants from 1935 to 1937, Gabler was traded to the Boston Bees for Wally Berger and $35,000 in June 1937. Gabler made a relief appearance for the Giants in Game 2 of the 1936 World Series against the New York Yankees. The Yankees won by a score of 18-4.

MICKEY COCHRANE. Cochrane was a catcher for the Philadelphia Athletics, who were owned by Connie Mack. He sponsored a professional Long Beach team during the 1945 Los Angeles Winter League season. Five years earlier, the Philadelphia A's were training at Anaheim, but his team's appearance at Recreation Park that same year caused a junior high school principal to close up classes for the day to give students a chance to catch the game. During the 1940 game, Mack would regularly hold up play in order to retrieve every foul ball, an overt act of frugality.

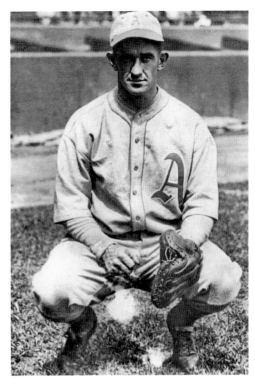

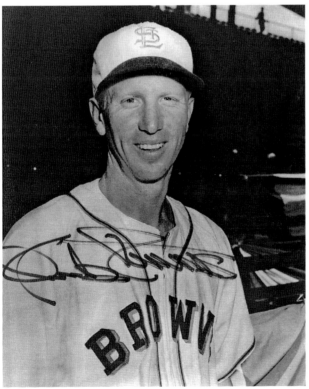

CHUCK STEVENS. Stevens played three years for the St. Louis Browns and six years for the Hollywood Stars in the Pacific Coast League, winning three championships with the Stars (1949, 1952, and 1953). Stevens's high school and American Legion teammates included Vern Stephens, Bob Lemon, and Bob Sturgeon, while his opponents included Jackie Robinson and Ted Williams. He homered off Satchel Paige in his first active game back after World War II military service. For more than 70 years, Stevens contributed to baseball and his fellow players both on and off the field.

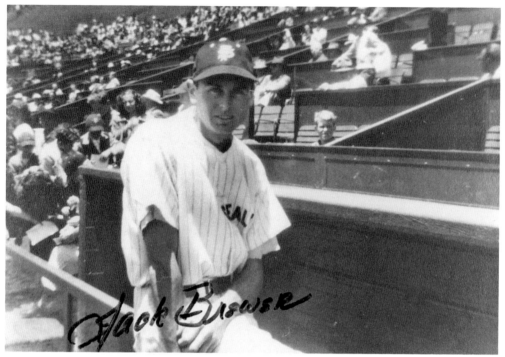

JACK BREWER. Brewer pitched for the New York Giants from 1944 until 1946, making his major-league debut on July 15, 1944. Here he poses in front of the dugout during his playing days with the San Francisco Seals of the Pacific Coast League in 1947. Brewer attended the University of Southern California and later pitched for Mel Ott's New York Giants from 1944 to 1946. A Long Beach Polytechnic High School attendee, Brewer appeared in 43 games and held a lifetime 4.36 ERA.

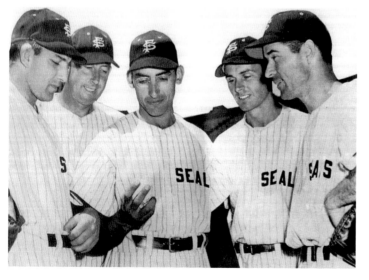

BREWER ON THE MOUND. Holding a baseball, Jack Brewer stands on the mound with some of his teammates from the San Francisco Seals of the Pacific Coast League. Brewer attended the University of Southern California and entered professional baseball in the Southern Association (Knoxville) in 1941.

BOB LEMON. Lemon signed as an amateur free agent with the Cleveland Indians in 1938. He pitched for the Indians from 1946 until 1958. Lemon worked alongside teammate Bob Feller to lift the 1948 Indians to a World Series championship against the Boston Braves by winning Game 2 (4-1) and Game 6 (4-3). He earned more than 20 victories seven times within a nine-year period and was inducted into the Baseball Hall of Fame in 1976.

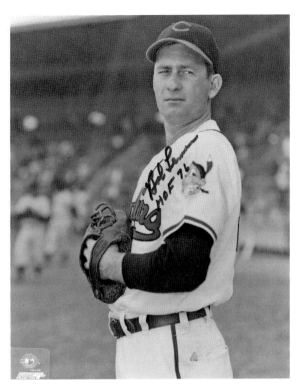

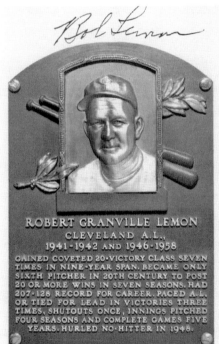

ROBERT GRANVILLE LEMON
CLEVELAND A.L.,
1941-1942 AND 1946-1958
GAINED COVETED 20-VICTORY CLASS SEVEN
TIMES IN NINE-YEAR SPAN. BECAME ONLY
SIXTH PITCHER IN 20TH CENTURY TO POST
20 OR MORE WINS IN SEVEN SEASONS. HAD
207-128 RECORD FOR CAREER. PACED A.L.
OR TIED FOR LEAD IN VICTORIES THREE
TIMES, SHUTOUTS ONCE, INNINGS PITCHED
FOUR SEASONS AND COMPLETE GAMES FIVE
YEARS. HURLED NO-HITTER IN 1948.

NATIONAL BASEBALL HALL OF FAME & MUSEUM
Cooperstown, New York

LEM'S PLACARD. Bob Lemon's Hall of Fame placard reads: "Robert Granville Lemon Cleveland A.L. 1941–1942 and 1946–1958. Gained coveted 20-victory class seven times in nine-year span. Became only sixth pitcher in 20th century to post 20 or more wins in seven seasons. Had 207–128 record for career. Paced A.L. or tied for lead in victories three times, shutouts once, innings pitched four seasons and complete games five years. Hurled no-hitter in 1948."

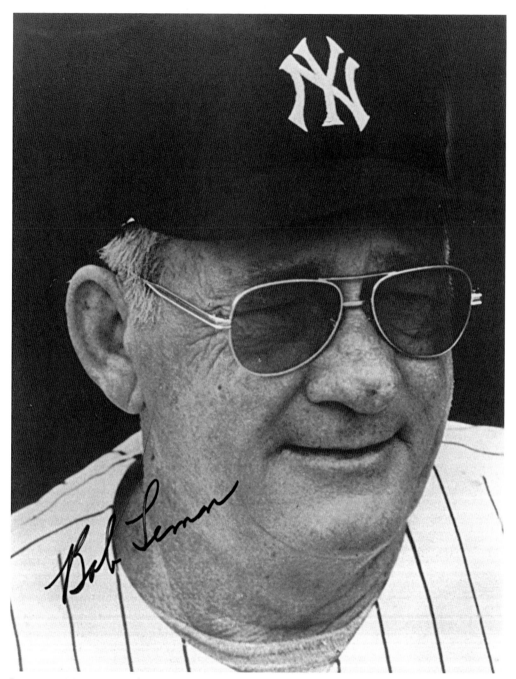

LEMON AS MANAGER. Bob Lemon led the 1978 New York Yankees to a World Series championship and was fired by Yankees' owner George Steinbrenner early in the 1979 season. He later returned to manage the Yankees late in 1981, beating the Milwaukee Brewers and Oakland A's, eventually winning the first two games of the World Series against the Los Angeles Dodgers before losing the next four. He continued managing the Yankees for a few weeks into the 1982 season before another Steinbrenner-enforced exit.

Player Statistics:

Year	Team	League	Won	Lost
1938	Oswego	Can.-Am.	0	0
1941	Wilkes-Barre	Eastern	0	1
1943-45	Military Service			
1946	Cleveland	AL	4	5
1947	Cleveland	AL	11	5
1948	Cleveland	AL	20	14
1949	Cleveland	AL	22	10
1950	Cleveland	AL	23	11
1951	Cleveland	AL	17	14
1952	Cleveland	AL	22	11
1953	Cleveland	AL	21	15
1954	Cleveland	AL	23	7
1955	Cleveland	AL	18	10
1956	Cleveland	AL	20	14
1957	Cleveland	AL	6	11
1958	Cleveland	AL	0	1
	San Diego	PCL	2	5
Minor League Totals			2	6
Major League Totals			207	128

Managerial Statistics:

Year	Team	League	Won	Lost
1970	Kansas City	AL	46	64
1971	Kansas City	AL	85	76
1972	Kansas City	AL	76	78
1977	Chicago	AL	90	72
1978	Chicago	AL	34	40
	New York	AL	48	20
1979	New York	AL	34	31
1981	New York	AL	11	14
1982	New York	AL	6	8
Totals			430	403

You and your guest are cordially invited to the unveiling of the monument dedicated to

BOB LEMON

induced into the
Baseball Hall of Fame
1976

Date:
Saturday, November 17, 2001

Time:
10:30 a.m.

Place:
Blair Field
4700 East 10th Street
Long Beach, California

Committee:
"Friends of Bob"

Jerry Cassaday
Ted Christensen
Monte Davis
Dr. John Elder
Fred Hauswirth
Dr. Criag Leonard
Tom Liken
Carl Roepke
Chuck Stevens
Bob Sturgeon
Don Tosh

We hope you can join us.

R.S.V.P.
Monte Davis

FRIENDS OF LEM. This was an invitation to a monument unveiling held at Blair Field in honor of Bob Lemon. The monument was placed on the site of the ball field in Long Beach where Lemon's playing days began. The ceremony was attended by a few of the players that grew up playing ball with him.

BOB STURGEON. Sturgeon is pictured at Recreation Park with part of the grandstand visible in the background. Born in Clinton, Indiana, Sturgeon played for five seasons with the Chicago Cubs between 1940 and 1947. He was traded to the Boston Braves in 1948.

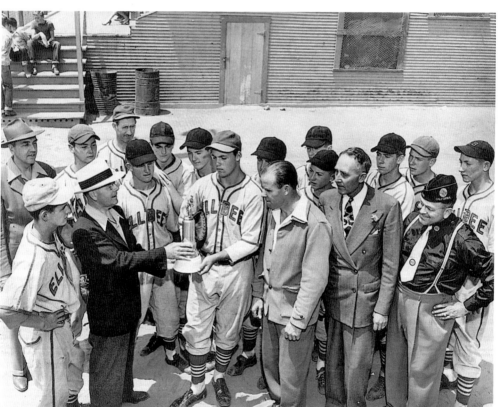

STATE CHAMPIONS. Harry Minor accepts a trophy after the Ell Bees triumphed over Modesto for the state championship at Recreation Park around 1944. At only 15 years old, Minor belted a home run out of Recreation Park, an accomplishment unheard of even for much more experienced players.

HARRY MINOR. Minor signed with the Pittsburgh Pirates in 1947 and the Philadelphia Athletics in the early 1950s. He is among the most prominent and successful talent scouts in all of baseball. He has worked closely in several roles with the New York Mets organization for the past four decades.

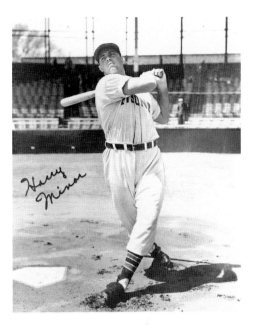

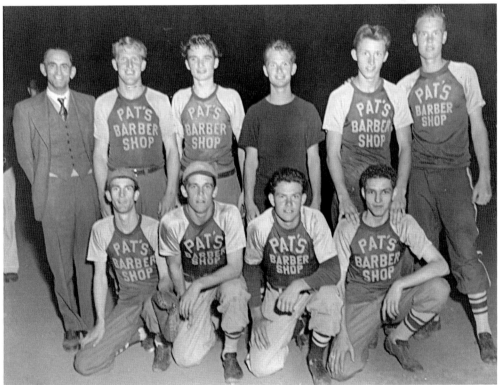

PAT'S BARBERSHOP SOFTBALL. This team was one of dozens active at Recreation Park in 1947. Softball was frequently the gateway for many players into baseball. Pictured from left to right are (first row) Bill Moore, Artie Boyd, Dick Hartzell, and Joe Klaren; (second row) Pat Patterson, Don Gill, Joe O'Brien, Chuck Warnick, Stan Crumm, and Roger Bolin.

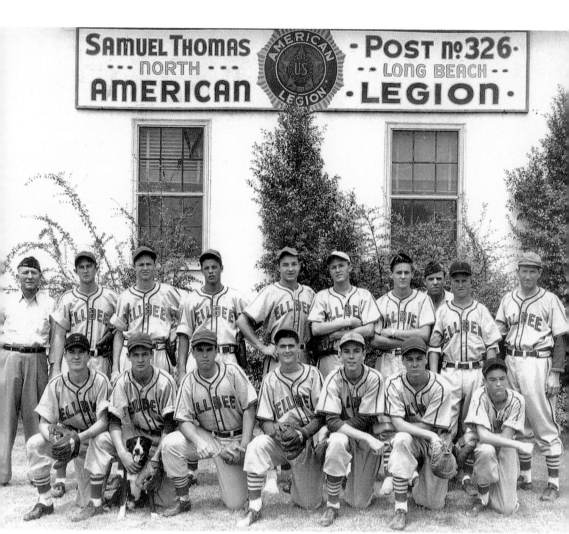

AMERICAN LEGION POST NO. 326. This image shows a mid-1940s-era lineup for Samuel Thomas American Legion Post No. 326. This team, known as the Ell Bees, featured many fine players, including future major leaguer Dick Cole. Bob Hughes was the team's coach and a scout for the St. Louis Cardinals, which helped in acquiring uniforms for the team during World War II. Pictured from left to right are (first row) Red Muir, John Crutchfield (with his dog Boots), Don Lee, Ken Gunsauls, Dick Angel, Dave Hughes, and Bob Harlocker; (second row) unidentified Legion representative, Dick Cole (Pittsburgh Pirates), Ken White, Harry Minor, Dick Ottle, Bill Backburn, Roy Anderson, unidentified Legion representative, Morley Bockman, and coach Bob Hughes.

WINNING LINEUP. Part of a 1944 Junior High School championship team poses in front of the bleachers at old Recreation Park. Intra-city junior high school playoffs, culminating in a championship series, were common.

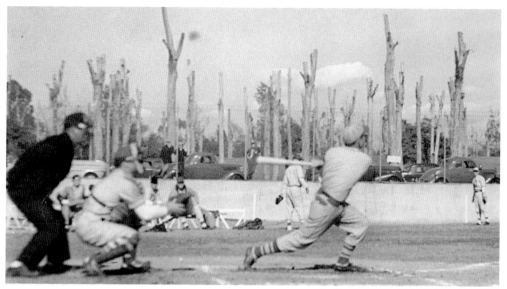

WILSON HIGH SCHOOL CHAMPS. A 1947 playoff game (California Interscholastic Federation) won by Wilson High School was held at Recreation Park. During World War II, gun emplacements had been stationed in the park, causing the trees to be radically trimmed for a clear skyward view.

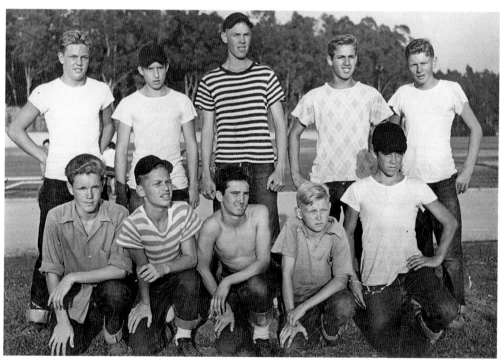

TWILIGHT LEAGUE. Before Pony League baseball was played in the city, the recreation department and school district sponsored a Twilight League. Pictured from left to right are the 1944 Summer League champions: (first row) Doug Thorsen, Chuck Warnick, Bill Moore, Ken Johnson, and Artie Boyd; (second row) Vance Thurston, Langdon Evans, Roger Bolin, Joe Newman, and Ollie Holmes.

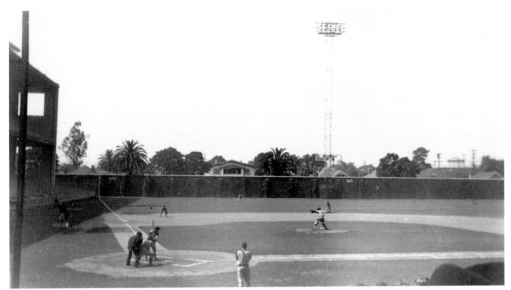

WRIGLEY FIELD, 1947. Artie Boyd is shown at bat for Long Beach Wilson at Wrigley Field in Los Angeles for the Southern California championship of 1947. Woodrow Wilson High School defeated John C. Fremont High School for the title.

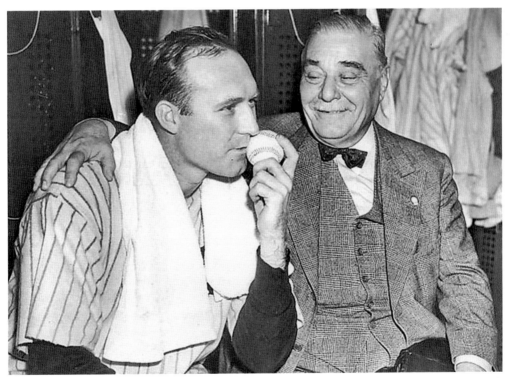

CHARLES "RED" RUFFING. Ruffing (left) and Jake Rupert (right) are pictured here in the New York Yankees clubhouse. Ruffing was a pitcher for the Boston Red Sox and the Yankees and was a six-time All-Star during his 22-year playing career. He played for Bill Feistner in local exhibition games.

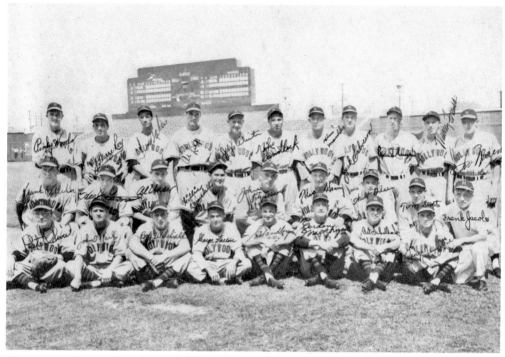

HOLLYWOOD STARS. The 1949 Hollywood Stars club featured two Long Beach major leaguers: Jack Salveson and Chuck Stevens. They are pictured together in the third row, fourth and third from the right respectively.

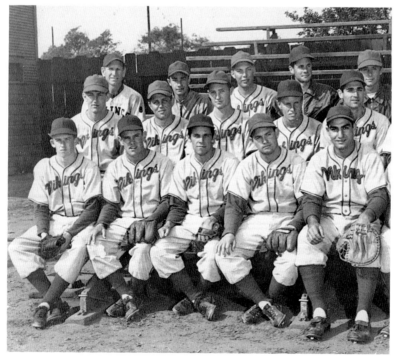

LONG BEACH CITY COLLEGE. The 1949 Long Beach City College Vikings baseball team was led by coach Al Johnson after his years at Woodrow Wilson High School. Coach Johnson is pictured in the third row on the far left.

THE FOUNDATIONS

PAIGE AND FELLER. A 1949 photograph depicts Satchel Paige and Bob Feller as teammates with the Cleveland Indians. Together on several occasions, Paige and Feller would bring their own barnstorming teams to play at Recreation Park.

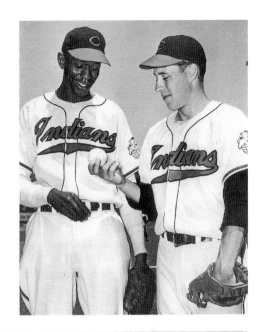

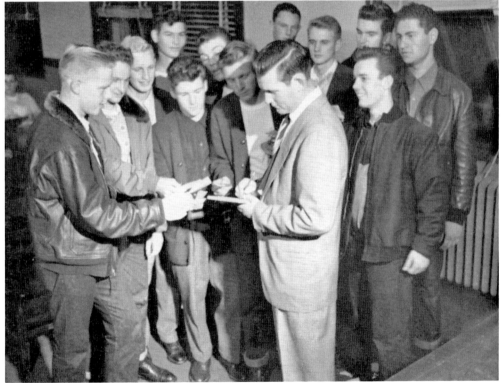

LEM'S ALMA MATER. Bob Lemon returned to his alma mater, Woodrow Wilson High School, in 1950 to sign a few autographs. A dominant, full-service pitcher from the mid-century era, Lemon led the American League in complete games five times and registered more that 20 complete games seven times.

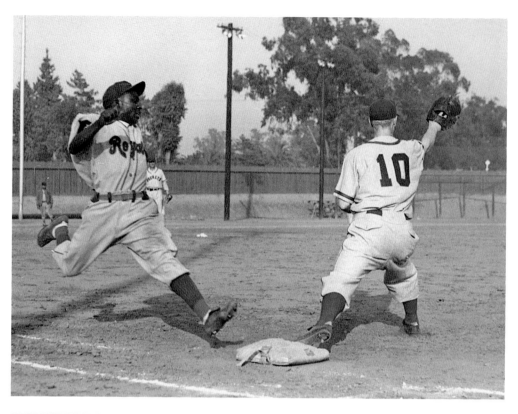

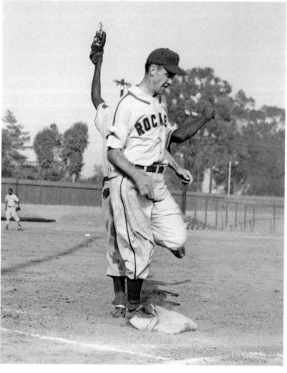

ROCKETS VERSUS ROYALS. Rockets first baseman Chuck Stevens fields a close throw in a game against the Royals dated somewhere around the late 1940s or the early 1950s.

CROSSING FIRST. A Rockets player crosses first, lifting the bag strap, as the opposing first baseman stretches out to make the play.

THE FOUNDATIONS

ROCKETS VERSUS ROYALS II. The Royals are at bat during a game against the Rockets at Recreation Park.

STEVENS ON ROCKETS. After playing with both the St. Louis Browns and the Hollywood Stars, Chuck Stevens played first base for the Long Beach Rockets in the late 1940s and early 1950s. Stevens is pictured here in position on the field at Recreation Park.

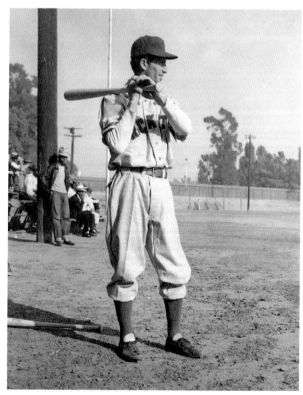

STEVENS ON DECK. Rockets player Chuck Stevens waits for his turn at bat against the Royals.

THE FOUNDATIONS

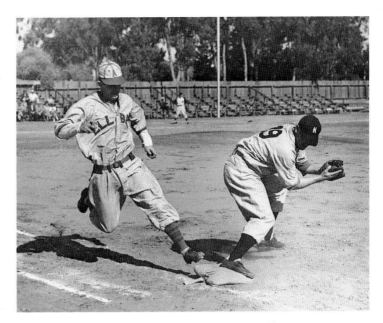

CLOSE AT FIRST. An Ell Bees player stretches out to reach first base in a close play. The Recreation Park seating and fence line can be seen in the background.

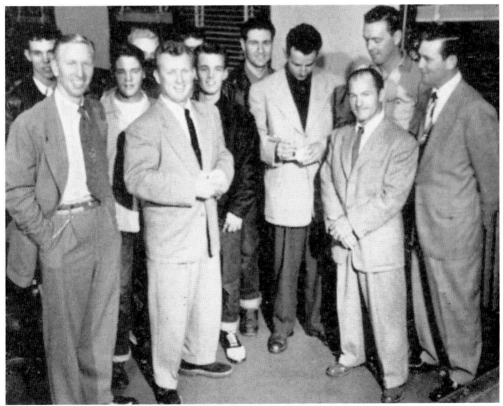

BIG-LEAGUE VISIT. This image shows several Long Beach major-league players on a 1950 visit to Woodrow Wilson High School. Pictured from left to right are Chuck Stevens, Eddie Bockman, Jack Salveson, Cliffey, Jack Graham, and Bob Lemon.

BASEBALL IN LONG BEACH

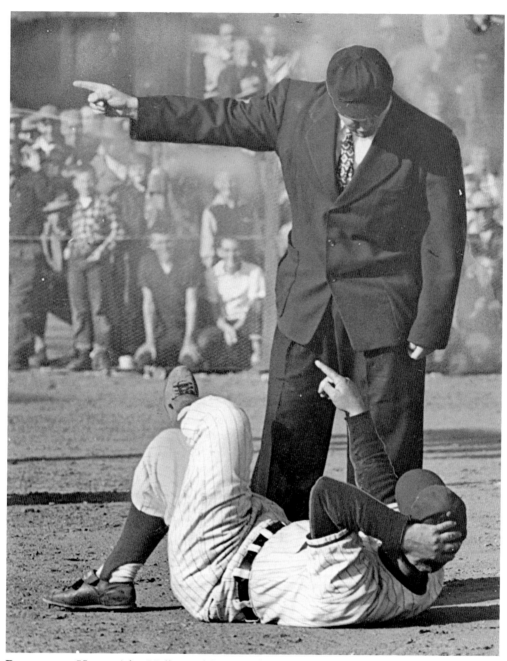

RELAXED AT HOME. After Hollywood Stars pitcher Solon Shaw threw at Los Angeles Angels batter Bob Usher, sending him crashing to the ground, umpire Emmett Ashford waved Usher to first. Stars manager Bobby Bragan stormed out of the dugout, eventually hurling his cap over Ashford's head. Ashford tossed him from the game. Umpire Al Mutart, in support of Ashford, ran in from second base for a few words with Bragan as the manager formed his "lie-down" strike position. Bragan eventually got up, and the Stars went on to win 6-4 at Recreation Park on April 4, 1954.

THE FOUNDATIONS

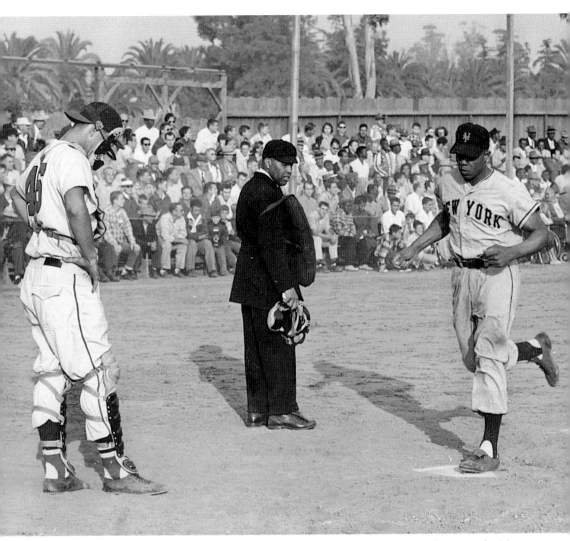

WILLIE MAYS. On November 5, 1955, Recreation Park played host to a game between the Negro League All-Stars and prominent local players. The umpires for the game included Emmett Ashford and Joe Reed. The photograph shows Willie Mays crossing home plate against a local team comprised of Jack Salveson, Dick Cole, Bob Sturgeon, Joey Amalfitano, Erv Palica, Bud Daley, Dick Wilson, Eddie Bockman, Bob Lemon, Chuck Stevens, Rocky Bridges, and Nelson Burbrink. Pictured from left to right are Nelson Burbrink, Emmett Ashford, and Willie Mays.

EMMETT ASHFORD. The first black umpire to reach the major leagues, Ashford worked in the American League after 12 years spent refining his craft in the Pacific Coast League. He spent five years at the major-league level and retired after calling the 1970 World Series between the Baltimore Orioles and the Cincinnati Reds.

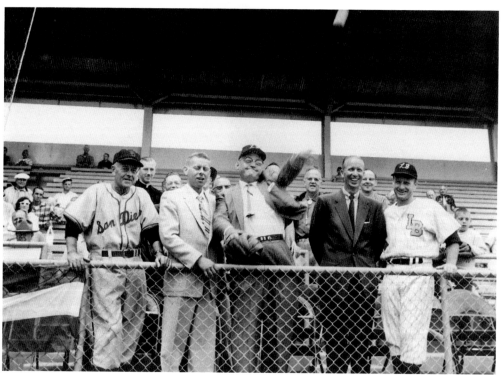

BLAIR FIELD DEDICATION. Long Beach mayor Raymond C. Kealer throws the honorable first ball at the dedication of Blair Field, named for local sportswriter and editor Frank T. Blair. The ceremony for the newly refurbished professional ballpark in Long Beach was on May 10, 1958. (Courtesy of the Long Beach Collection, Long Beach Public Library.)

THE FOUNDATIONS

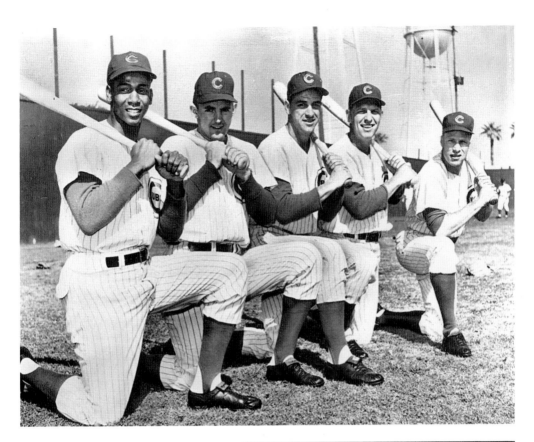

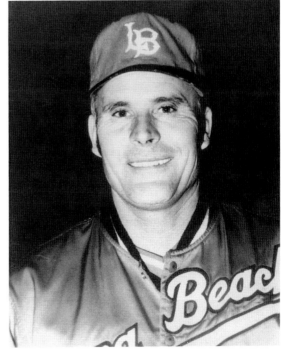

ERNIE BANKS. Banks was a 1977 Baseball Hall of Fame inductee, and he was a member of the Chicago Cubs during their training camp at Blair Field in 1961. Banks was one of the first players to report to camp that year.

NICK HOPKINS. Hopkins signed with the Boston Red Sox and played professionally for five years. He played with the Long Beach Rockets before joining the Long Beach Nitehawks softball team, where he held the position of shortstop for 18 years. A 15-time Western Softball Congress All-Star, he is arguably the best softball shortstop of all-time.

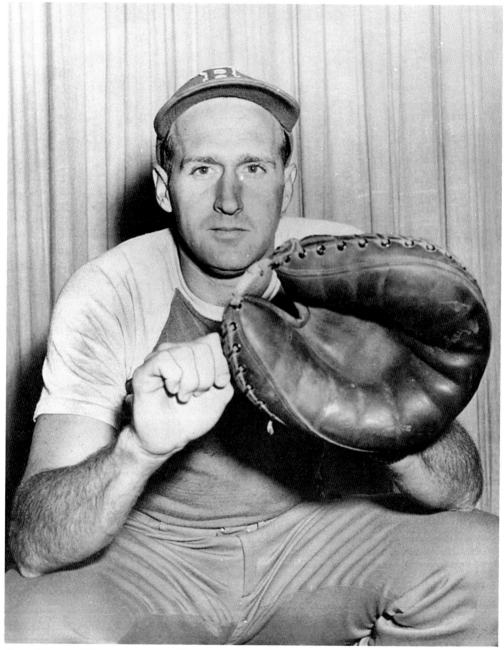

STAN WHITE. White is considered by many to be the greatest softball catcher who ever lived. He caught for seven national championship teams and was voted all-American in each of them.

IRVIN "RED" MEAIRS. Meairs's name is synonymous with the Long Beach Nitehawks softball team that he owned and managed for many years. After being signed into the Los Angeles Dodgers organization in 1943, Red returned to play with the Long Beach Rockets. He led three teams to world titles and was part of seven more International Softball Congress world championships as a player.

HOWARD, FORD, BOYD, AND HOLLINGSWORTH. This image shows an early 1960s civic introduction of Yankees favorites to baseball fans by Lakewood High School baseball coach Artie Boyd. Pictured from left to right are longtime New York Yankees Elston Howard and Whitey Ford (partially obscured), Boyd, and longtime local sportswriter Hank Hollingsworth.

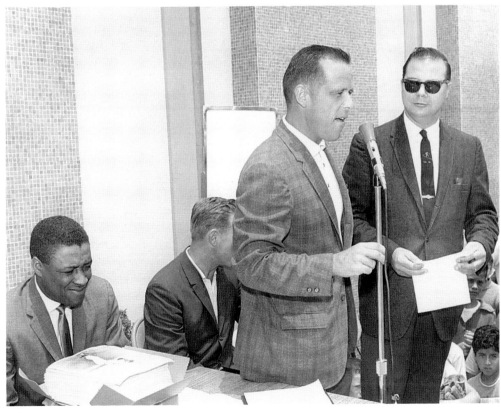

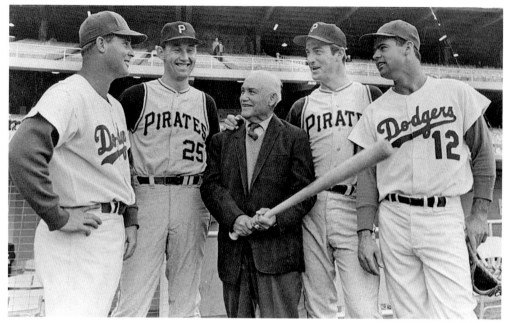

COMMON GROUND. This picture shows a quick reunion between two Dodgers, two Pirates, and their former coach, Mike Romero. All four players got their starts in the Long Beach baseball community. Pictured from left to right are Ron Fairly, Tommie Sisk, Romero, Jim Pagliaroni, and Bob Bailey.

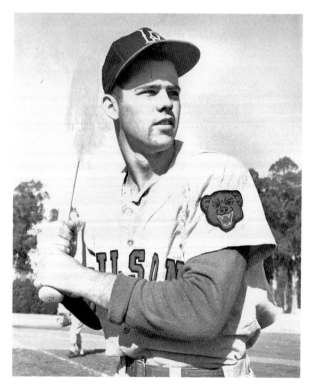

BOB BAILEY. A 1961 Woodrow Wilson High School graduate and a CIF (California Interscholastic Federation) Player of the Year, Bailey is seen here in his Wilson uniform. He was originally signed by the Pittsburgh Pirates in 1961 for a record-shattering $175,000 and went on to compete in 1,931 games with a lifetime .257 batting average and 773 runs driven in.

THE FOUNDATIONS

BAILEY FOR THE DODGERS. On December 1, 1966, the Pittsburgh Pirates traded Bailey along with Gene Michael to the Los Angeles Dodgers for Maury Wills. Bailey spent two seasons with the Dodgers and was purchased by the Montreal Expos in October 1968.

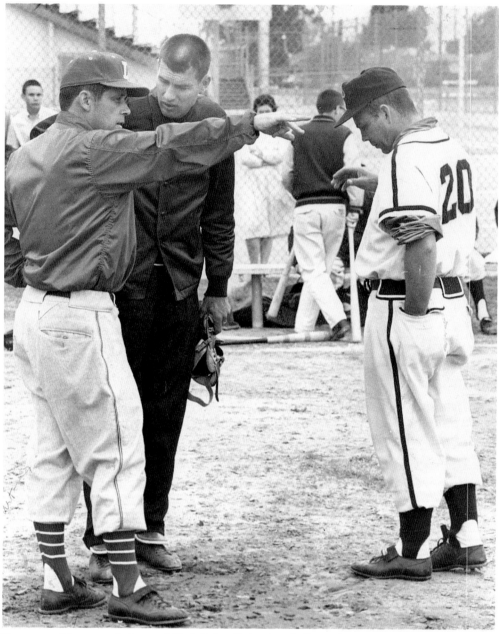

BOYD AND HERBOLD. Lakewood High School's first baseball coach, Artie Boyd (left), discusses a call with the umpire at Blair Field during a game between Lakewood and Long Beach Polytechnic High School in 1961 while Poly coach John Herbold (right) listens in.

THE FOUNDATIONS

A Day with Casey.
Legendary Long Beach
City College baseball
coach Joe Hicks (seated,
far left) organized a
Casey Stengel Baseball
Tournament at Blair Field
in 1962. Harry Minor
(seated, center) insured
that Stengel (the "Old
Perfessor," far right)
would be in attendance
for the game. Seated
behind Minor is former
Los Angeles Dodger
and New York Mets
player Norm Sherry.

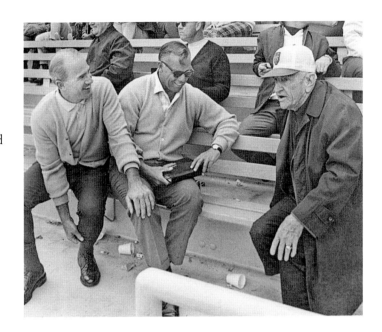

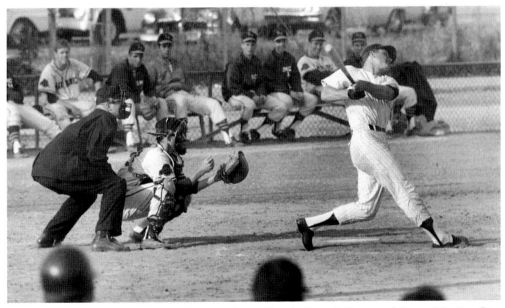

Joe Reed. Reed umpires a game between Long Beach City College and Santa Monica City College in 1962. He played baseball at Long Beach State University in 1955, and from the 1960s through the 1980s Reed was a familiar presence as an umpire around the region. He served as a leader and mentor to many future umpires, including the late Charlie Williams (National League 1982–1999, Major League Baseball 2000–2001), who was the first African American umpire to work behind home plate during a World Series game.

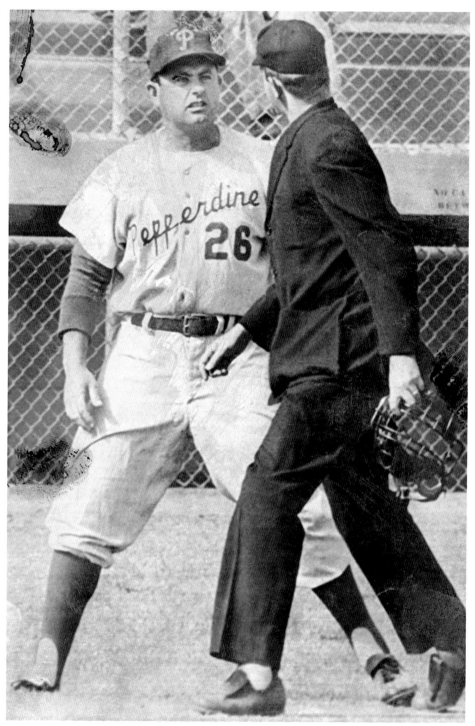

DIFFERENT OPINION. In April 1964, Pepperdine coach Gary Marks disputes Joe Reed's call in the sixth inning in a game against Long Beach State. Reed called a Long Beach State base runner out but immediately changed the call after the Pepperdine third baseman dropped the ball.

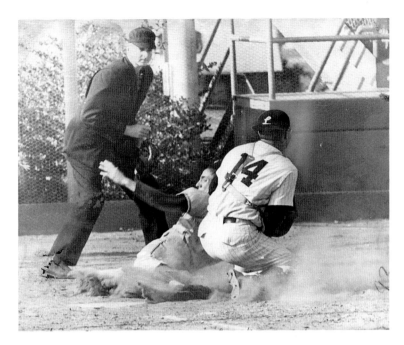

SAFE! St. Anthony High School's Spud O'Neil steals home, scoring the third run in the fifth inning of this 1964 game versus Lakewood High School. Switching sides in later years, O'Neil became the third baseball coach at Lakewood after Artie Boyd and John Herbold.

LEGION TOURNAMENT. A 1963 American Legion tournament game is umpired by Joe Reed at Blair Field.

BASEBALL IN LONG BEACH

TOUGH PLAY. Joe Reed watches carefully as a runner tries to make it back to the bag. Note the position of the ball compared with the runner's hand; was he safe?

HOSTING LAS VEGAS. A Las Vegas team visits Blair Field for a game. Umpire Joe Reed calls a close play at second base.

THE FOUNDATIONS

OUT AT HOME. This image shows a 1969 game between Millikan High School and Sante Fe. Umpire Joe Reed looks on as Millikan catcher Tim Marshall sets up to tag base runner John Connelly for the second out of the third inning. Rand Rasmussen made the throw from shortstop to Marshall.

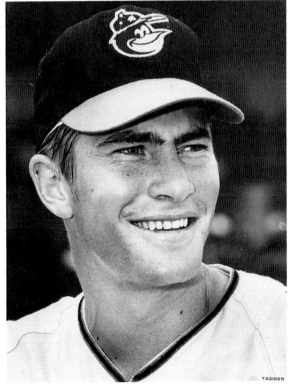

BOBBY GRICH. A first-round draft pick by the Baltimore Orioles in 1967 and a six-time all-star, Grich played for a total of 17 seasons (7 with the Baltimore Orioles and 10 with the California Angels), contributing 1,833 hits and 864 runs driven in. He holds four consecutive Golden Glove awards and several major-league records as a second baseman.

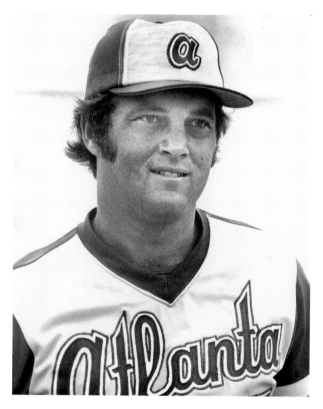

JEFF BURROUGHS. Burroughs was the 1969 CIF Player of the Year and a first-round draft pick by the Washington Senators that same year. Burroughs played for 16 seasons with the Senators, Texas Rangers, Atlanta Braves, Seattle Mariners, Oakland A's, and Toronto Blue Jays. Awarded the 1974 American League MVP award, he hit 41 home runs and drove in 114 runs during the 1977 season. After an enormously successful playing career, Burroughs led a Long Beach Little League team to back-to-back Little League World Series championships in 1992 and 1993.

TONY GWYNN. Inducted into the MLB Hall of Fame in 2007, Gwynn was drafted by the San Diego Padres in 1981 and played for 20 seasons with that same team. He earned eight batting titles while hitting over .300 in 19 consecutive seasons, including a .394 average for the 1994 season. Gwynn is undeniably among the best pure hitters ever to play the game.

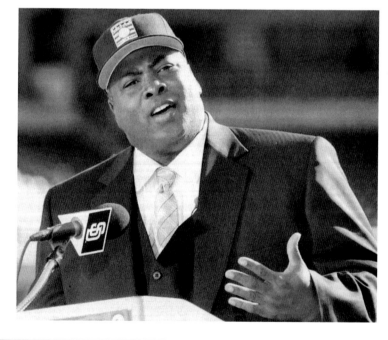

LONG BEACH
MAJOR LEAGUERS

According to legendary coach John Herbold, "Per square mile, Long Beach has delivered more major-league players than any other city in the United States." There is a good reason to believe him. Every decade has its players, and in the modern era, players from Long Beach are abundant. Jack Rothrock was the first contribution by Long Beach to Major League Baseball. From that beginning in 1925, more than 65 players have reached the highest level of play over the decades since.

From the founding of Recreation Park to the few efforts launched to build a baseball stadium seating as many as 55,000 in Long Beach to bring in a major-league franchise, a common thread can be traced through each passing decade of baseball activity within the city. Although players faced many challenges differing in kind and scope unique to their times, each began with fundamentals. Yet the fundamentals weren't enough. As suggested earlier, a few of the factors that made Long Beach baseball special were the mild weather and geography of the locale mixed with an early focus on strongly supporting civic recreation.

From that near-perfect beginning, the growth of players depended on a group of dedicated baseball believers in the form of coaches and supporters willing to share their knowledge, love, and talents for the greater good, often at a substantial personal cost. Their support seems to be the true reason why so many players ascended their level of play from roots within a city affectionately dubbed "Iowa by the sea" to playing around the nation and the world. A few arrived at the highest level of play for only a very short time, but this in no way alters the depth of their journey.

A gallery representing each of the city's five main high schools—Long Beach Polytechnic, Woodrow Wilson, David Starr Jordan, Robert A. Millikan, Lakewood, and St. Anthony—showcase a wide variety of players who got their start on Long Beach ball fields.

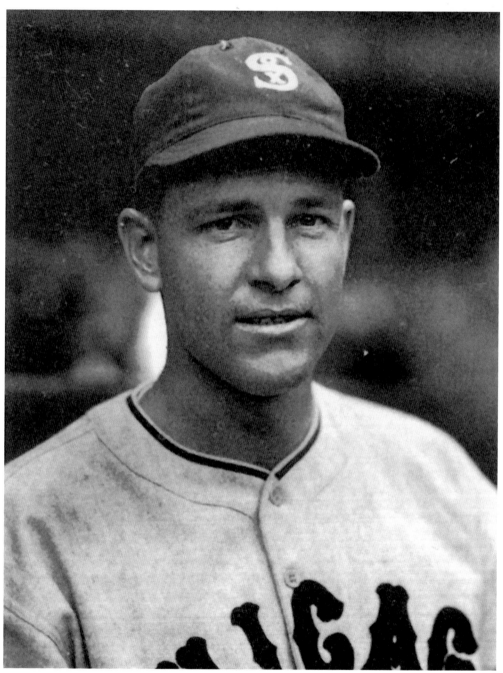

JACK ROTHROCK. Born March 14, 1905, in Long Beach, Rothrock attended Long Beach Poly High School and played eight seasons for the Boston Red Sox starting in 1925. He ended the 1932 season playing for the Chicago White Sox after he and Charlie Berry were traded for Bennie Tate, Smead Jolley, and Johnny Watwood along with $7,500. He finished his playing career with the St. Louis Cardinals and the Philadelphia Athletics, collecting 924 career hits for a .276 average that included 327 runs driven in.

WALTER "KIT" CARSON. Carson, a Long Beach Poly High School product, played outfield for Walter Johnson's 1934 and 1935 Cleveland Indians. He made 21 game appearances with a .250 batting average.

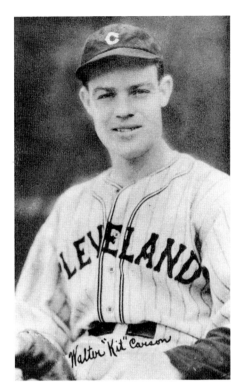

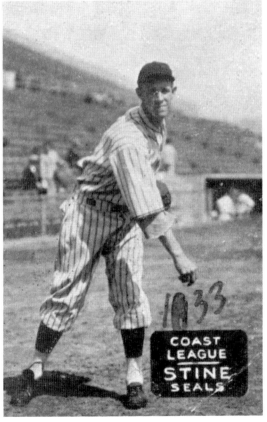

LEE STINE. This Long Beach Poly High School graduate took the mound for the 1934 and 1935 Chicago White Sox. Acquired by the Cincinnati Reds in 1936, Stine had his most prominent season, appearing in 40 games with a 5.03 ERA. Purchased by the New York Yankees in 1936, Stine went on to pitch in four games for the Yankees in 1938.

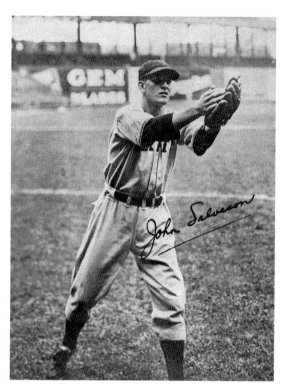

JACK SALVESON. Salveson tossed three shutouts in 1943 for the Cleveland Indians. A Long Beach Poly High School graduate, he began his career playing for the 1933 and 1934 New York Giants and was traded to the Pittsburgh Pirates for Leon Chagnon. Salveson finished his career playing for the 1943 and 1945 Cleveland Indians, earning a lifetime 3.99 ERA.

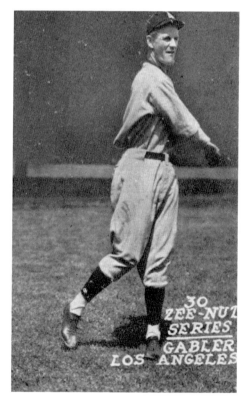

FRANK GABLER. Called "The Great Gabbo," Gabler threw for the New York Giants from 1935 until 1937 and was traded along with $35,000 to the Boston Bees for Wally Berger. He posted the third lowest ERA in the National League for the 1936 season and was purchased by the Chicago White Sox from the Bees in 1938. Gabler attended Long Beach Poly High School.

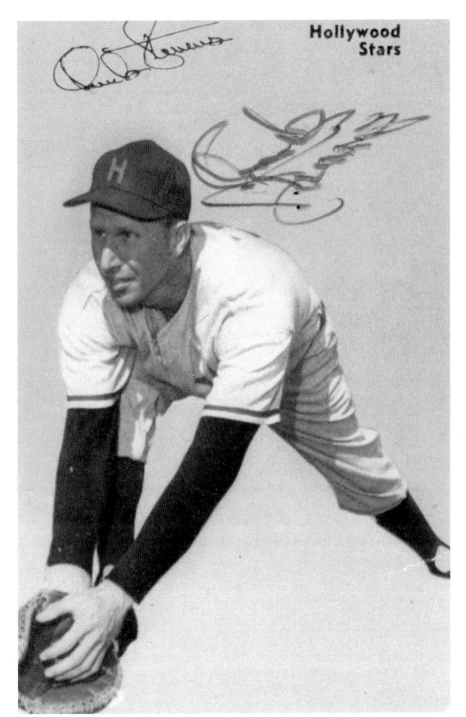

CHUCK STEVENS. Stevens played first base for the St. Louis Browns in 1941, 1946, and 1948. He hit .321 for the Hollywood Stars to finish up the 1948 season and posted a .297 season average for the 1949 Hollywood Stars in combination with his rock-solid defensive skills. Stevens attended Long Beach Poly High School.

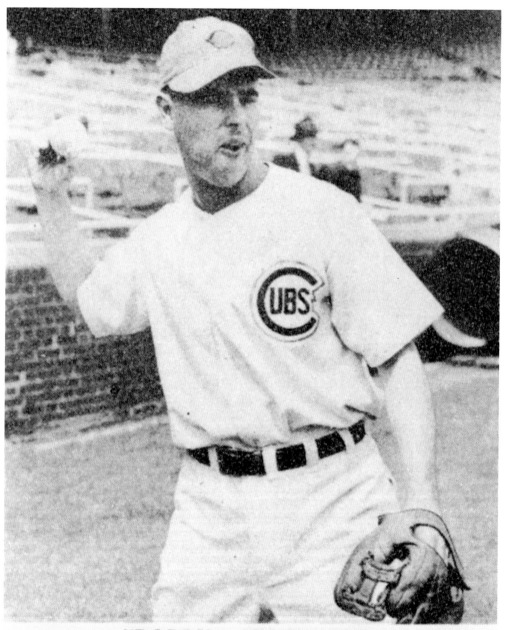

"BOBBY" STURGEON
Shortstop, Chicago, N.L.

BOB STURGEON. Brought over from the St. Louis Cardinals to the Chicago Cubs in 1939, Sturgeon was another Long Beach Poly High School product. He was active with the Cubs as an infielder, playing shortstop, second base, and third base, from 1940 through 1947. He was traded in March 1948 to the Boston Braves for Dick Culler and was the sixth youngest player in the National League for the 1940 season.

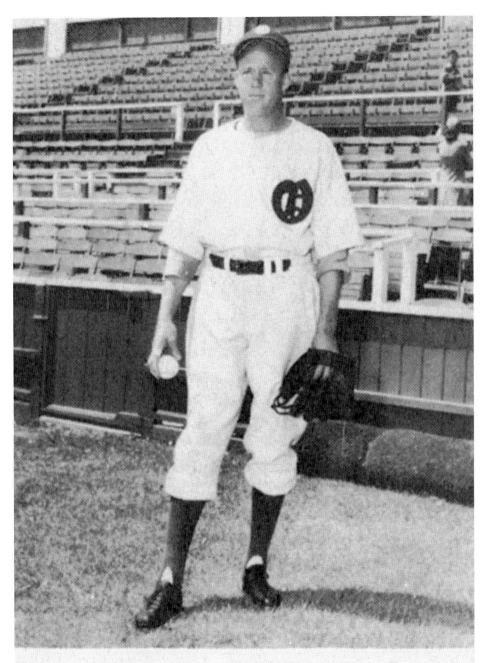

RALPH BUXTON
Oaks Pitcher 6

RALPH BUXTON. Buxton pitched in five games for Connie Mack's 1938 Philadelphia Athletics and then returned 11 years later in 1949 to play for Casey Stengel's 1949 New York Yankees team. Buxton also attended Long Beach Poly High School.

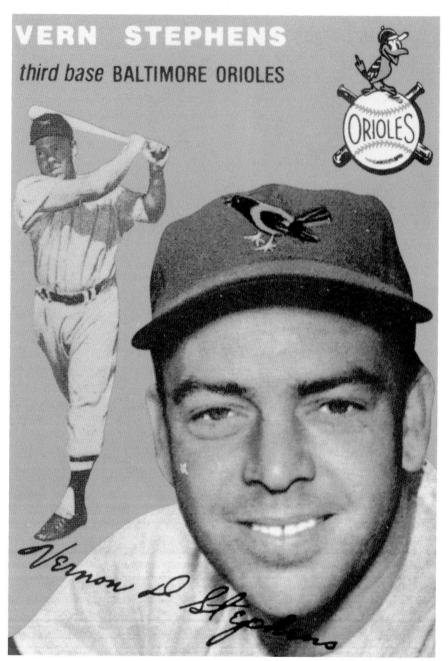

VERN STEPHENS. Signed by the St. Louis Browns prior to the 1938 season, Stephens played for seven seasons with the Browns before being traded with Jack Kramer to the Boston Red Sox in 1947 for Roy Partee, Jim Wilson, Al Widmar, Eddie Pellagrini, Pete Laydon, Joe Ostrowski, and $310,000. Predominantly a shortstop, he was an eight-time all-star who batted .307 during the 1946 season. In 1949, Stephens was second in the American League slugging percentage to his teammate Ted Williams; Williams had .650 versus Stephens's .539. Stephens went to Long Beach Poly High School.

REX CECIL. Cecil appeared in 18 games during the 1944 and 1945 seasons with the Boston Red Sox. A Long Beach Poly High School product, he threw at total of 106 innings with a 5.18 ERA.

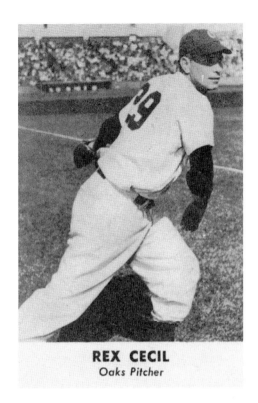

REX CECIL
Oaks Pitcher

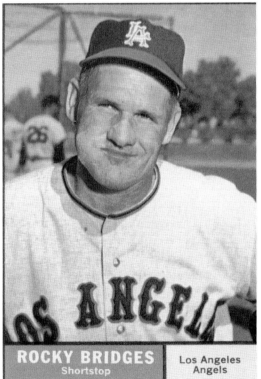

ROCKY BRIDGES
Shortstop — Los Angeles Angels

ROCKY BRIDGES. Signed by the Brooklyn Dodgers prior to the 1947 season, Bridges played for Brooklyn in 1951 and 1952. He was traded to the Cincinnati Reds in 1953 and played the next four seasons with them before being selected off waivers by the Washington Senators in 1957. This Long Beach Poly High School player finished his playing career after spending time with the Detroit Tigers, Cleveland Indians, St. Louis Cardinals, and Los Angeles Angels. He was an all-star in 1958 and held a .247 lifetime batting average after 11 seasons of play.

PIRATES

TOMMIE SISK pitcher

TOMMIE SISK. Sisk joined the Pittsburgh Pirates before the 1960 season and pitched for seven seasons with them before being traded with Chris Cannizarro to the San Diego Padres for Ron Davis and Bobby Klaus in 1969. Sisk was traded to the Chicago White Sox during mid-season in 1970. He appeared in 316 major-league games with a 3.92 ERA and had the ninth best win-loss percentage in the National League in 1966 with .667. Sisk had been a Long Beach Poly High School hurler.

BRIAN MCCALL. McCall signed with the Chicago White Sox as an amateur free agent in 1961. He had attended Long Beach Poly High School. McCall appeared in seven games for the White Sox as an outfielder during the 1962 and 1963 seasons, earning a lifetime .200 average.

Brian McCall

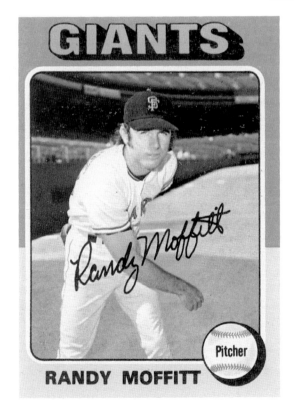

RANDY MOFFITT

RANDY MOFFITT. Drafted in the first round (18th pick overall) by the 1970 San Francisco Giants, Moffitt pitched for the Giants in 10 consecutive seasons before signing with the Houston Astros (February 1982) and then the Toronto Blue Jays (February 1983) as a free agent. He appeared in 534 games with a 3.65 ERA. The Long Beach Poly High School graduate finished 34 games for the Giants in 1973 to be the ninth best in the league.

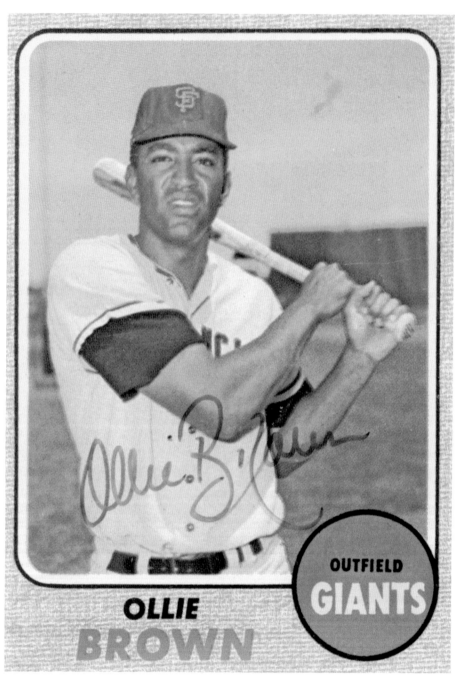

OUTFIELD

GIANTS

OLLIE
BROWN

OLLIE BROWN. Brown joined the San Francisco Giants before the 1962 season and first appeared playing outfield with them in 1965. During a 13-season career, Brown played with the San Diego Padres, Oakland A's, Milwaukee Brewers, Houston Astros, and Philadelphia Phillies. He was eighth in the 1970 National League with 34 doubles. Brown appeared in 1,221 games, knocked in 454 runs, and finished up with a .265 lifetime average. He was among those who learned the game at Long Beach Poly High School.

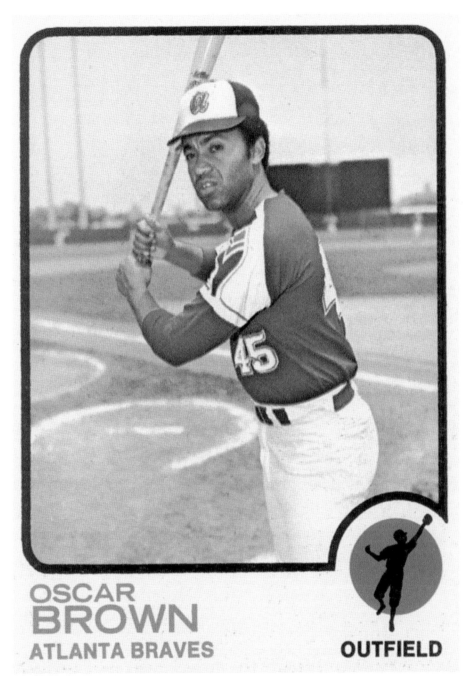

OSCAR
BROWN
ATLANTA BRAVES

OUTFIELD

OSCAR BROWN. Ollie Brown's brother, Oscar, was drafted by the Cincinnati Reds in the 18th round of the 1965 amateur draft but did not sign. He was drafted again in 1966 by the California Angels in the fifth round, but again he chose not to sign. In June 1966, he was drafted by the Atlanta Braves in the first round (seventh pick overall) and signed. He played outfield for Atlanta between 1969 and 1973, appearing in 160 games while recording a .244 average. Like his brother, Oscar played for Long Beach Poly High School.

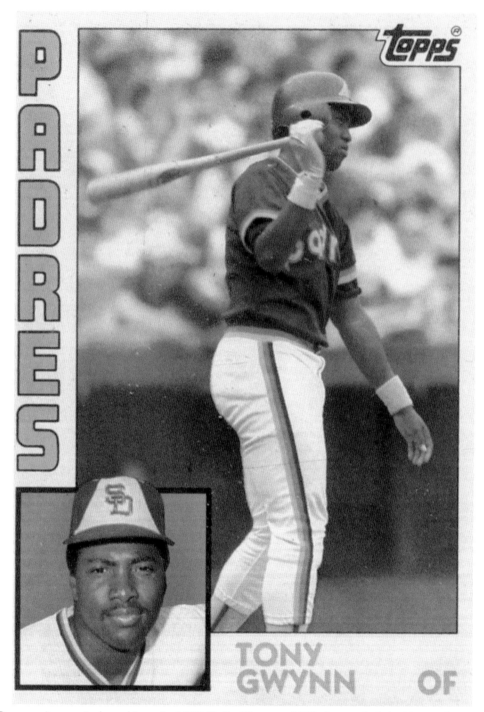

GWYNN AGAIN. Inducted into the MLB Hall of Fame in 2007, Gwynn led the National League in hits in 1984 (213), 1986 (211), 1987 (218), 1989 (203), 1994 (165), 1995 (197, tied with Dante Bichette), and 1997 (220). Gwynn won five Gold Glove awards for fielding between 1986 and 1991. He graduated from Long Beach Poly High School.

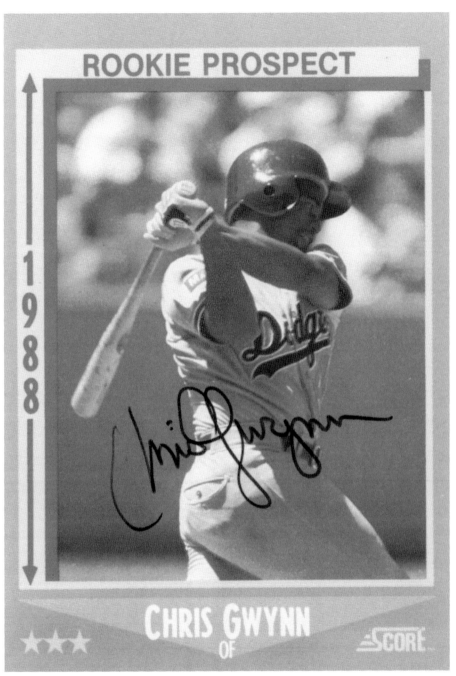

ROOKIE PROSPECT

1988

CHRIS GWYNN
OF

★★★

SCORE

CHRIS GWYNN. The younger brother of Tony Gwynn, Chris Gwynn, was the Dodgers' first round (10th overall) selection in the 1985 amateur draft. Gwynn played his first five seasons with the Los Angeles Dodgers before spending the 1992 and 1993 seasons with the Kansas City Royals. He returned to the Dodgers for 1994 and 1995 and finished up with the San Diego Padres in 1996. In 599 game appearances, he tallied 263 hits, drove in 118 runs, and had a .261 career average. Like his brother, Long Beach Poly High School was his alma mater.

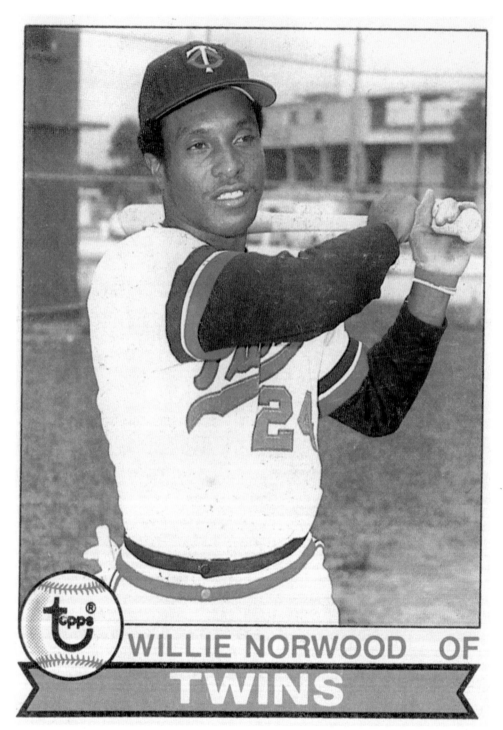

WILLIE NORWOOD OF
TWINS

WILLIE NORWOOD. Norwood appeared in 294 games for the Minnesota Twins from 1977 to 1980 as a designated hitter and outfielder. A former Long Beach Poly High School player, Norwood's major-league totals were 18 home runs, 93 runs batted in, and a .242 lifetime average.

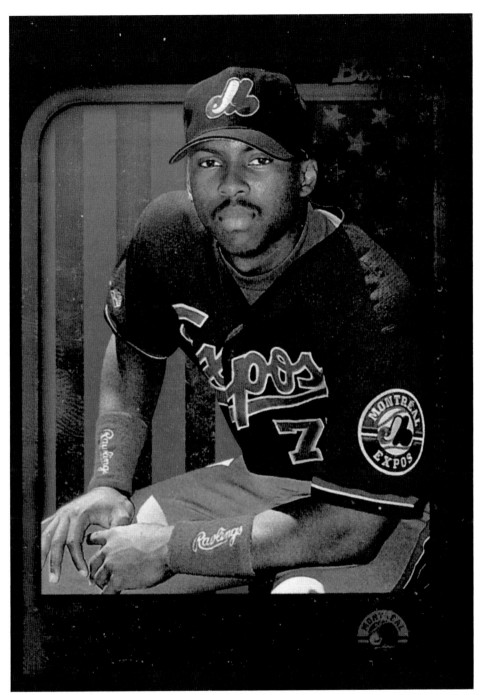

MILTON BRADLEY. Bradley was drafted by the Montreal Expos in 1996 and signed despite a commitment to Long Beach State. As a high school senior he hit .341 with 15 stolen bases. He played for the Cleveland Indians, Los Angeles Dodgers, Oakland Athletics, and San Diego Padres during eight seasons. In 11 post-season appearances, he collected a .310 batting average with four home runs. Bradley played at Long Beach Poly High School.

BASEBALL IN LONG BEACH

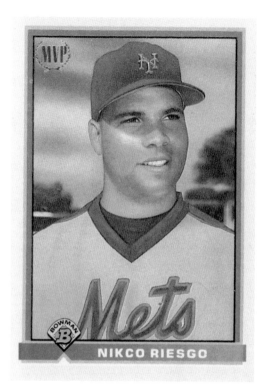

NIKCO RIESGO. Riesgo appeared in four games for the 1991 Montreal Expos who were managed by Buck Rodgers, tallying seven at bats with a hit, three walks, and a strike out. He played with many clubs after originally being drafted by the Milwaukee Brewers in 1985, when he chose not to sign. Riesgo is another notable Long Beach Poly High School product.

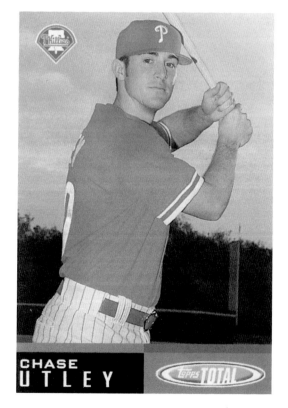

CHASE UTLEY. The Los Angeles Dodgers drafted Utley in 1997, but he chose not to sign. In 2000, he signed with the Philadelphia Phillies after being drafted in the first round (15th pick overall). During five seasons with the Phillies, Utley's batting average has ascended each year (.239, .266, .291, .309, and .322). He is a two-time all-star second baseman and posted the third-highest batting average in the National League for the 2007 season at .322, trailing only Matt Holiday (.340) and Chipper Jones (.337). Utley hails from Long Beach Poly High School.

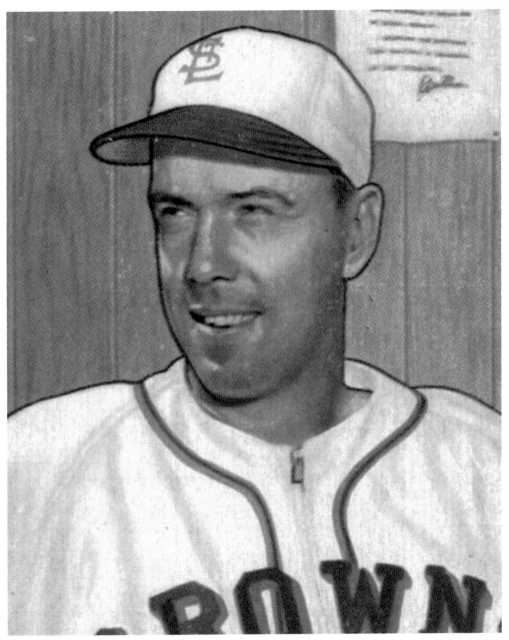

JACK GRAHAM. Graham played first base and outfield for the Brooklyn Dodgers and New York Giants in 1946. In 1949, he appeared in 137 games for the St. Louis Browns, hitting 24 home runs and knocking in 79 runs. He was seventh in the National League for home runs with 14 in 1946 and fifth with 24 in 1949. The 1949 National League season saw fellow Long Beach player Vern Stephens second in home runs with 39 to the league's home run leader Ted Williams (43). Graham played high school ball at Woodrow Wilson High School in Long Beach.

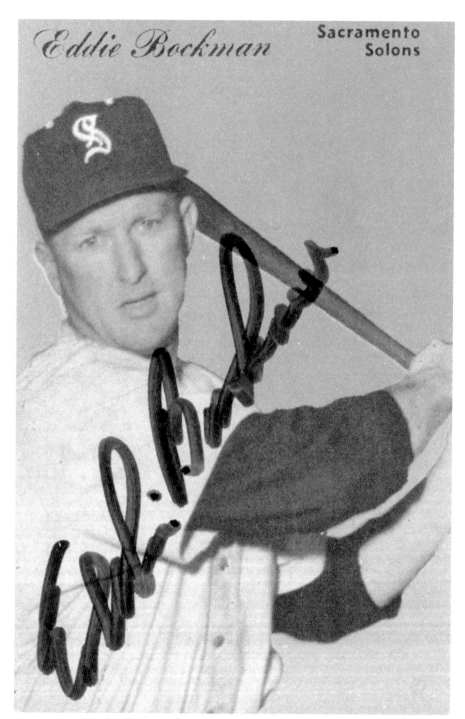

Eddie Bockman

Sacramento
Solons

EDDIE BOCKMAN. The 1946 New York Yankees included Bockman, who played for the Cleveland Indians in 1947. He was acquired by the Pittsburgh Pirates for the 1948 season and returned to the Pirates for the 1949 season. An infielder, Bockman appeared in 199 games, driving in 56 runs with a .230 lifetime average. Bockman is also a Woodrow Wilson High School graduate.

Bob Lemon

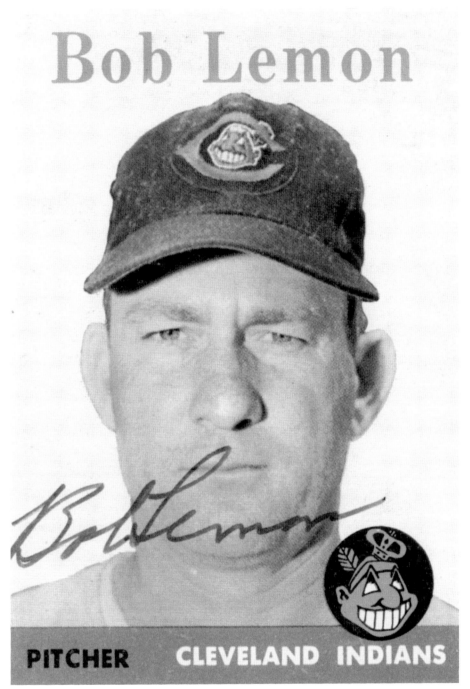

PITCHER CLEVELAND INDIANS

BOB LEMON. One of the finest pitchers of the 1940s and 1950s, Lemon had the most American League wins in 1950 and tied for most wins in 1954 (with Indians teammate Early Wynn) and 1955 (with the Yankees' Whitey Ford and Red Sox's Frank Sullivan). He won two games in the 1948 World Series and threw in four all-star games. The former Woodrow Wilson High School player won 20 games or more in seven separate seasons and entered the MLB Hall of Fame in 1976.

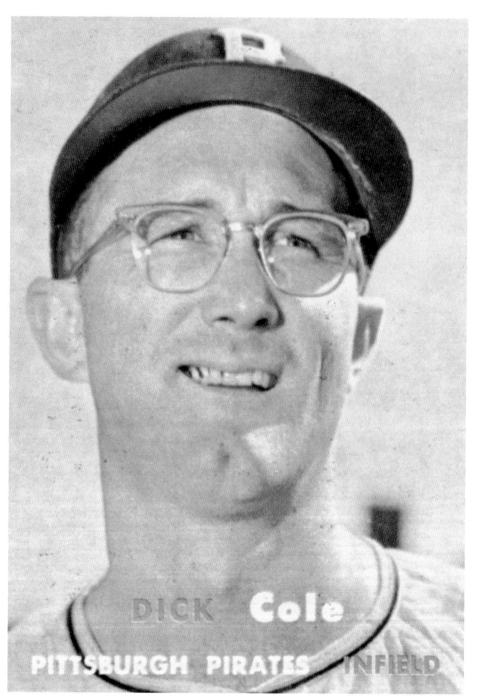

DICK COLE. An infielder signed by the St. Louis Cardinals before the 1943 season, Cole was traded to the Pittsburgh Pirates in 1951. He played for the Pirates for five seasons at second base, third base, and shortstop. The Woodrow Wilson High School graduate had 1,215 major-league at bats, 107 RBIs, and a lifetime .249 average. He finished his baseball career with the Milwaukee Braves in 1957.

BUD DALEY. Daley was signed by the Cleveland Indians prior to the 1951 season and made his major-league debut on September 10, 1955. He played for three seasons with the Indians and three and a half seasons with both the Kansas City Athletics (1958–1961) and the New York Yankees (1961–1964). As a pitcher, Daley was a five-time all-star with a lifetime 3.91 ERA in 248 games. He won Game 5 of the 1961 World Series as a member of the New York Yankees. Daley hailed from Woodrow Wilson High School.

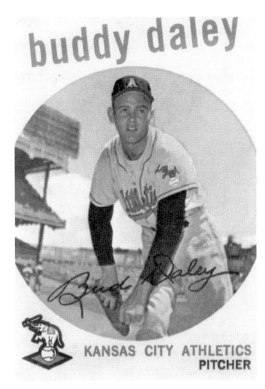

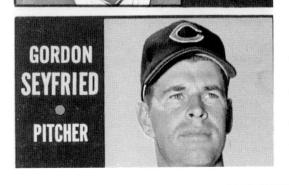

GORDON SEYFRIED. Seyfried appeared in five games for the 1963 and 1964 Cleveland Indians, pitching 109 innings with a 3.62 ERA. A Woodrow Wilson High School product, he won 17 games for Lancaster of the Eastern League in 1958.

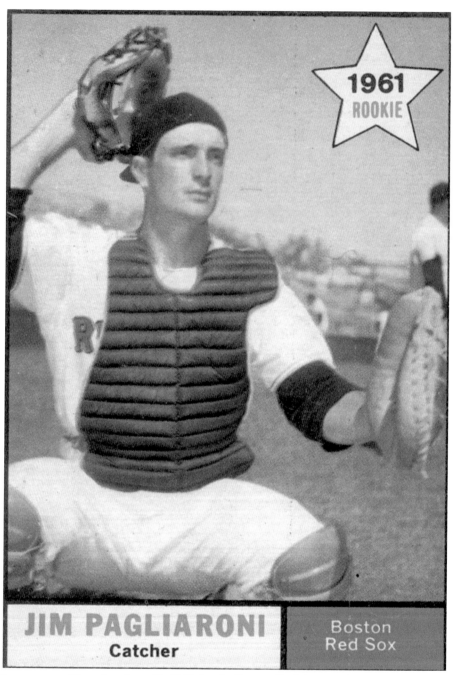

JIM PAGLIARONI
Catcher

Boston
Red Sox

JIM PAGLIARONI. Signed on June 17, 1955, by the Boston Red Sox, Pagliaroni was a catcher for the Red Sox in 1955 and from 1960 to 1962. He was known for his clutch abilities. He was traded to the Pittsburgh Pirates in 1962, playing for the Pirates from 1963 to 1967. In 1968 and 1969, he played for the Oakland Athletics and the Seattle Pilots (who became the Milwaukee Brewers). During 11 seasons, Pagliaroni had 2,465 at bats, knocked in 326 runs, and posted a lifetime .252 average. His baseball skills evolved at Woodrow Wilson High School.

JIM DUCKWORTH. A Woodrow Wilson High School graduate, Duckworth originally signed with the Brooklyn Dodgers prior to the 1957 season but was eventually picked up by the Washington Senators from the Cincinnati Reds in a 1962 Rule 5 draft. From 1963 through 1966 Duckworth worked primarily as a relief pitcher. In 97 career games he threw 267 innings, and in 1965 he posted a 3.94 ERA.

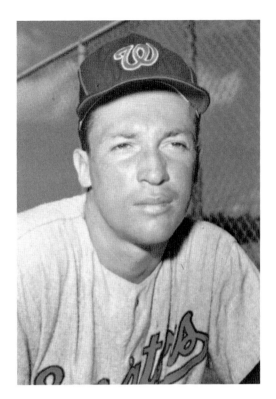

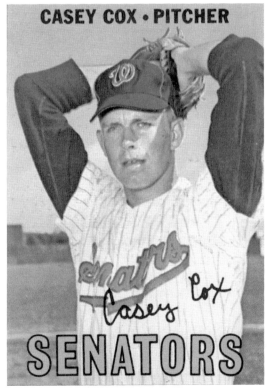

CASEY COX. Cox pitched for the Washington Senators from 1966 to 1971 and was traded by the Texas Rangers to the New York Yankees in 1972. He threw in 66 games as a strong-armed relief specialist during the 1966 season, tying Jack Aker of the Kansas City Athletics for the second-highest number of appearances for the year. A Woodrow Wilson High School graduate, Cox started many double plays by throwing his strong sinker.

PIRATES

BOB BAILEY 3rd base

BOB BAILEY. In a playing career spanning 17 seasons, Bailey played for the Pittsburgh Pirates, Los Angeles Dodgers, Montreal Expos, Cincinnati Reds, and Boston Red Sox. He was primarily a third baseman. In 1966, Bailey was traded with Gene Michael by the Pirates to the Dodgers for Maury Wills. During an exceptionally long career, "Beetles" Bailey had 6,082 at bats, drove in 773 runs, and had a lifetime .257 batting average. He was a Woodrow Wilson High School graduate.

ED CROSBY. Father of the Oakland A's Bobby Crosby, Ed Crosby played for the St. Louis Cardinals from 1970 to 1973 before being traded to the Cincinnati Reds. From 1974 to 1976 Crosby played infield positions for the Cleveland Indians. He collected 149 hits in 677 major-league at bats for a .220 career average. He posted one hit in two at bats during the 1973 NLCS (National League Championship Series). Crosby played for Woodrow Wilson High School.

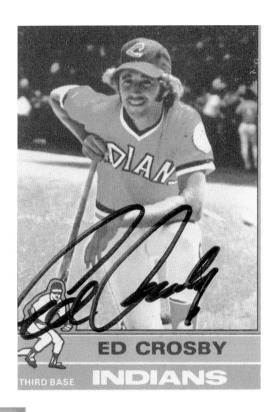

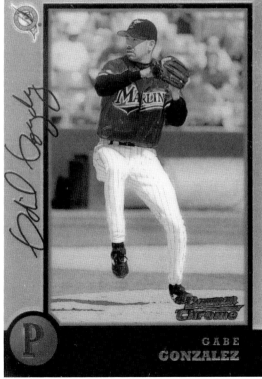

GABE GONZALEZ. Signed by the Florida Marlins in 1995, Gonzalez made his pitching debut for the Marlins on April 1, 1998. A Woodrow Wilson High School graduate, he ranks second in NCAA career saves with 46. With Portland (Double-A) and Charlotte (Triple-A) in 1997, he made 66 appearances and posted a 2.41 ERA.

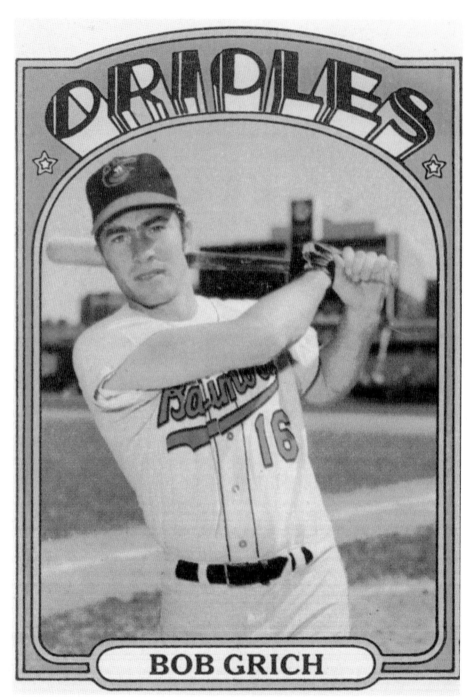

ORIOLES

BOB GRICH

BOBBY GRICH. A six-time all-star with four Golden Glove awards, Grich played for 17 major-league seasons. His first seven were with the Baltimore Orioles and the next 10 were with the California Angels. His .543 slugging percentage was the best in the American League in 1981. He drove in 864 runs in his career and had a .266 lifetime average. In Long Beach, Grich was a Woodrow Wilson High School mainstay.

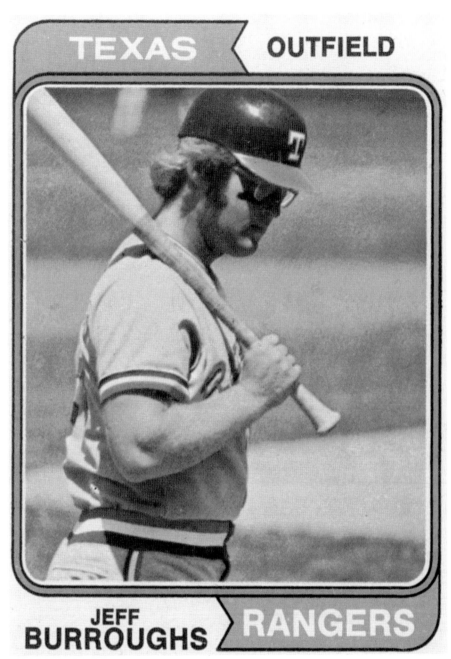

TEXAS **OUTFIELD**

JEFF BURROUGHS **RANGERS**

JEFF BURROUGHS. A first-round first pick by the Washington Senators in 1969, Burroughs played for 16 seasons with the Senators, Texas Rangers, Atlanta Braves, Seattle Mariners, Oakland A's, and Toronto Blue Jays. A two-time all-star and the 1974 American League MVP with a league-leading 118 RBIs, he posted a slugging percentage over .500 in four separate seasons. With 5,536 at bats and 882 runs driven home, Burroughs finished with a .439 slugging percentage and a .261 lifetime batting average. His son Sean became the second Burroughs first-round pick in 1998. Jeff played for Woodrow Wilson High School in Long Beach.

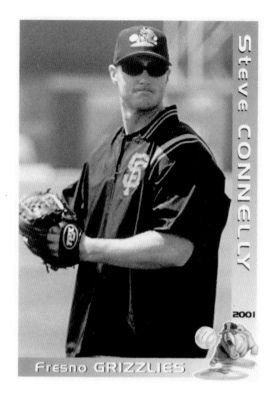

STEVE CONNELLY. Drafted by the Oakland Athletics in 1995, Connelly made his debut on the mound on June 28, 1998, for Oakland. After three appearances, he posted a 1.93 ERA in 4.7 innings pitched. Connelly played high school ball for Woodrow Wilson High School in Long Beach.

DAVE MARSHALL. Signed by the Los Angeles Angels prior to the 1963 season, Marshall made his debut in 1967. He played outfield for three seasons with the San Francisco Giants, three for the New York Mets, and one for the San Diego Padres in 1973. With a total of 1,049 at bats, he collected 114 RBIs and had a career .246 batting average. Prior to the big leagues, Marshall starred at Lakewood High School.

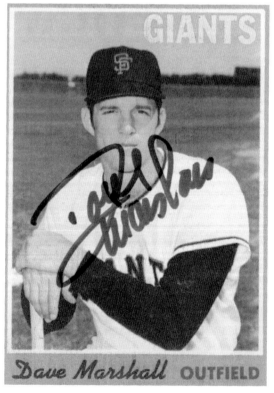

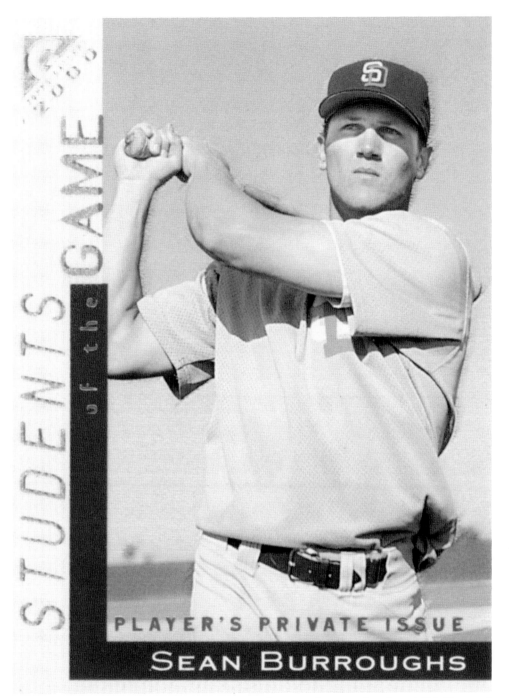

STUDENTS of the GAME

PLAYER'S PRIVATE ISSUE

SEAN BURROUGHS

SEAN BURROUGHS. Signed by the San Diego Padres as a first-round pick in 1998, Burroughs played four seasons with the Padres before being traded in 2005 to the Tampa Bay Devil Rays for pitcher Dewon Brazelton. In 2004, Burroughs was ninth in singles in the National League with 128. During five seasons with the Padres and Devil Rays, Burroughs knocked in 134 runs and held a .280 career average. He played high school ball at Woodrow Wilson High School.

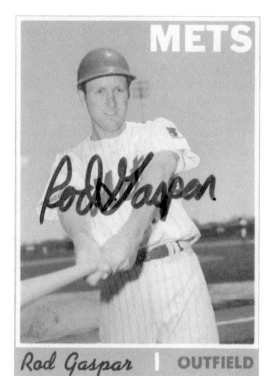

Rod Gaspar | OUTFIELD

ROD GASPAR. A product of Lakewood High School and Long Beach State, Gaspar was drafted by the New York Mets in 1966 but did not sign. He was drafted again by the Mets in the secondary phase of the 1967 draft and signed. Playing outfield for two seasons with the Mets and two with the San Diego Padres after a trade in 1970, Gaspar contributed his defensive skills. He appeared with the Mets in the 1969 World Series against the Baltimore Orioles.

TONY MUSER. A Lakewood High School star, Muser signed with the Boston Red Sox as an amateur free agent before the 1967 season. During nine seasons as a first baseman with the Red Sox, Chicago White Sox, Baltimore Orioles, and the Milwaukee Brewers, he became known for his consistency in regularly hitting around .285 with exceptionally strong fielding skills. His lifetime average is .259.

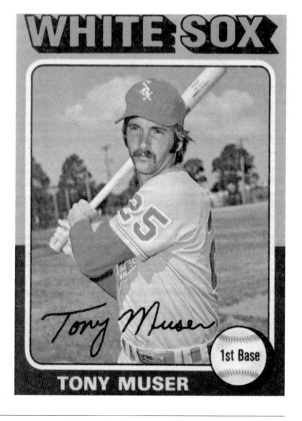

TONY MUSER | 1st Base

BRUCE ELLINGSEN. Drafted by the Los Angeles Dodgers in 1967, Ellingsen was traded to the Cleveland Indians in 1974 in exchange for Pedro Guerrero. The Lakewood High School star's major-league debut for the Indians occurred on July 4, 1974. He made pitching appearances in 16 games, tossing 42 innings with a 3.21 ERA.

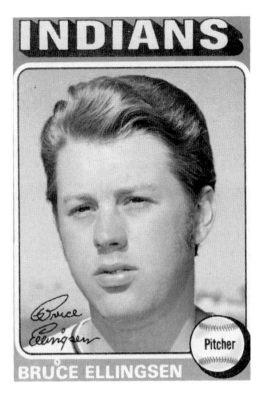

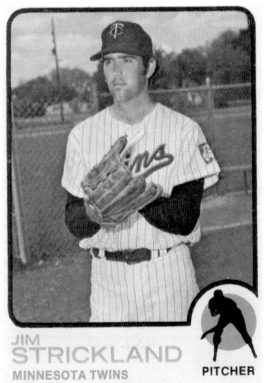

JIM STRICKLAND. A former player with Lakewood High School, Strickland was signed by the Los Angeles Dodgers prior to the 1964 season. He was then drafted by the Minnesota Twins in the 1970 minor-league draft. He pitched for Minnesota for three seasons from 1971 to 1973, winning his debut appearance against the California Angels in two innings of work, fanning four consecutive hitters. In 60 games he threw 77.3 innings for a career ERA of 2.68.

JOHN FLANNERY — SS, 2B

JOHN FLANNERY. Drafted by the California Angels in 1975, Flannery was traded to the Chicago White Sox in 1977. As a strong defensive shortstop and third baseman, he appeared in seven games for White Sox manager Bob Lemon. He was a product of Lakewood High School.

FLOYD CHIFFER. The California Angels drafted Chiffer in 1974, and the St. Louis Cardinals drafted him in 1977. He chose not to sign with either team. Instead he signed with the San Diego Padres after the 1978 draft, making his debut pitching performance with the Padres on April 7, 1982. In 81 game appearances, Chiffer threw 130 innings and had a 4.02 lifetime ERA. The Lakewood High School graduate's first major-league victory came against the Los Angeles Dodgers.

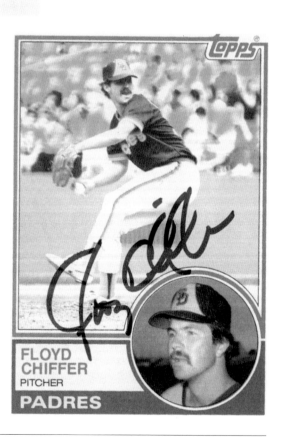

FLOYD CHIFFER
PITCHER
PADRES

MIKE FITZGERALD. A former Lakewood High School star, Fitzgerald signed with the New York Mets in the 1978 draft. A multi-position player, Fitzgerald was primarily a catcher but also spent time playing various infield and outfield positions. His first two seasons were spent behind home plate with the Mets, and the next seven seasons saw him play various positions for the Montreal Expos. He finished playing for the California Angels in 1992. During 10 seasons he had 545 hits and 293 RBIs with a complete .235 batting average.

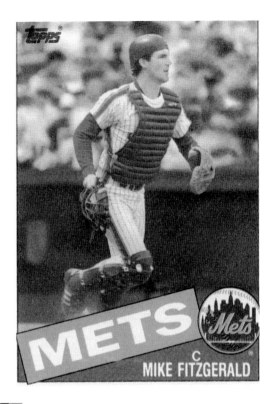

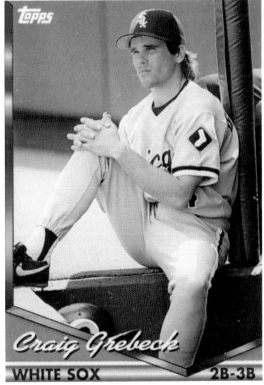

CRAIG GREBECK. Picked by the Chicago White Sox in the 1986 draft, Grebeck was a utility infielder for the White Sox for six seasons before being traded to the Florida Marlins in 1996. The Lakewood High School product signed as a free agent with the Anaheim Angels in late 1996 and with the Toronto Blue Jays in 1997, finishing up with the Boston Red Sox in 2001. During 12 seasons he tallied a .261 lifetime batting average with 518 hits and 187 RBIs.

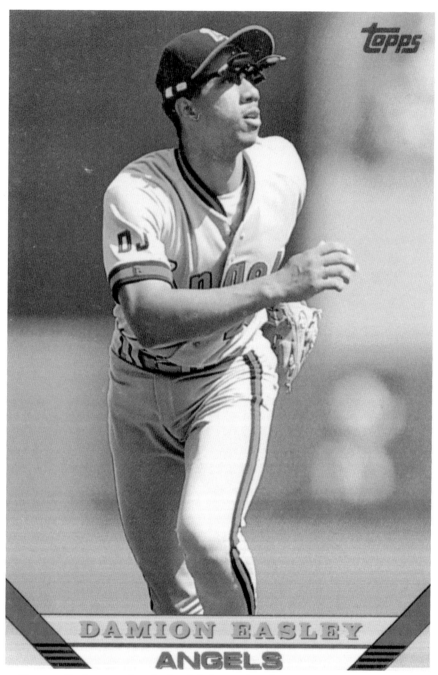

DAMION EASLEY

ANGELS

DAMION EASLEY. Easley signed with the California Angels on May 24, 1989. For 16 seasons he has played infield positions and been a designated hitter for the Angels, Detroit Tigers, Tampa Bay Devil Rays, Florida Marlins, and Arizona Diamondbacks. He currently plays for the New York Mets (as of 2007). Easley was an all-star selection in 1998 and was ninth in the league in triples in 2001. To date, the former Lakewood High School mainstay has 5,168 at bats, 157 home runs, 640 RBIs, and a cumulative .252 average.

LARRY CASIAN. Drafted by the Minnesota Twins in 1987, Lakewood High School graduate Casian played his first five seasons for the Twins before joining the Cleveland Indians, Chicago Cubs, Kansas City Royals, and Chicago White Sox to fill out nine seasons of service. His 1993 season with Minnesota stands out as a wild ride with a 6.03 ERA in spring training, a six-week elbow injury, and a 0.60 ERA during his first 42 games followed by a 12.34 ERA in his last 12. Casian pitched in 245 games for 240.7 innings with a lifetime 4.56 ERA.

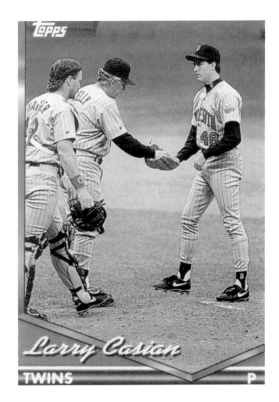

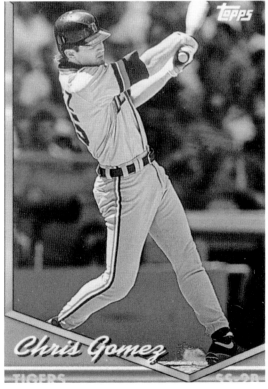

CHRIS GOMEZ. Gomez was drafted by the California Angels in 1989 but did not sign. Instead he chose to sign with the Detroit Tigers in 1992. During 15 seasons he has played for the Tigers, San Diego Padres, Tampa Bay Devil Rays, Minnesota Twins, Toronto Blue Jays, Baltimore Orioles, and Cleveland Indians. He hit .364 as a Padre against the New York Yankees in the 1998 World Series. To date, the Lakewood High School star has collected 1,156 hits and 467 RBIs with a .261 average.

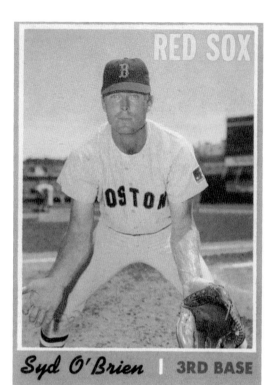

Syd O'Brien | 3RD BASE

SYD O'BRIEN. In four seasons of play between 1969 and 1972, O'Brien played for the Boston Red Sox, Chicago White Sox, California Angels, and Milwaukee Brewers. Originally signed by the Red Sox prior to the 1964 season, the Millikan High School star played mostly infield positions. He had 242 career hits, 100 RBIs, and a .230 lifetime average.

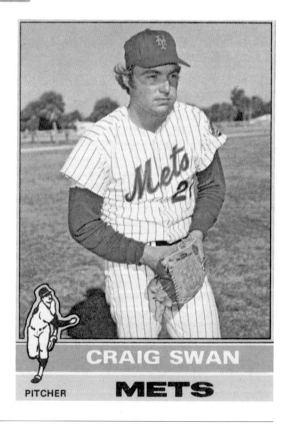

CRAIG SWAN

PITCHER METS

CRAIG SWAN. Originally drafted by the St. Louis Cardinals in 1968, Swan did not sign, choosing instead to join the New York Mets after the 1972 draft. A Millikan High School star, Swan pitched for the Mets during 12 seasons from 1973 to 1984, holding the lowest ERA in the National League for 1978 at 2.43. His lifetime ERA is 3.74 with 1,235.7 innings pitched and 673 strikeouts.

DAVE FROST. A Millikan High School product, Frost began his pitching career with the Chicago White Sox but spent the majority of his time with the California Angels before finishing up with the Kansas City Royals. He played for six seasons from 1977 to 1982 and went 16-8 for the California Angels in 1979, tying for the 10th lowest ERA in the American League for the year amongst Mike Flanagan, Ron Guidry, Dennis Eckersley, and Jack Morris.

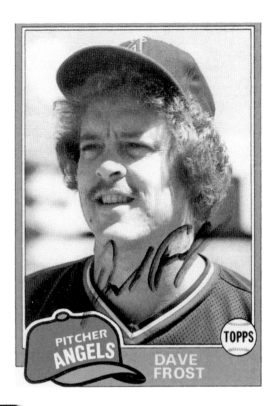

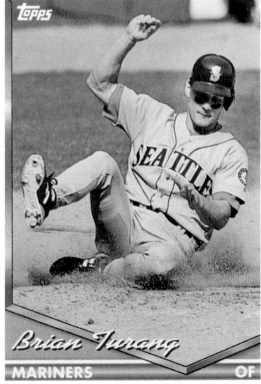

BRIAN TURANG. A Millikan High School graduate, Turang finished as the Pacific Coast League's ninth-ranked hitter in 1993. In his first 24 games for the Seattle Mariners, he reached base 22 times. During two seasons with the Mariners (1993 and 1994), he appeared in 78 games with 56 hits and 15 RBIs, holding a .222 career average.

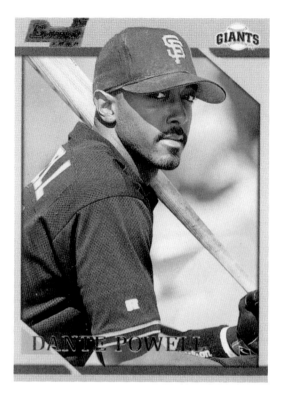

DANTE POWELL. Powell was a first-round draft pick by the San Francisco Giants in 1994. He demonstrated substantial athleticism and significant power potential mixed with speed and agility. In four total seasons, the Millikan High School product spent three with the Giants and one with the Arizona Diamondbacks. In 74 plate appearances, he tallied 20 hits and five RBIs for a .270 lifetime average.

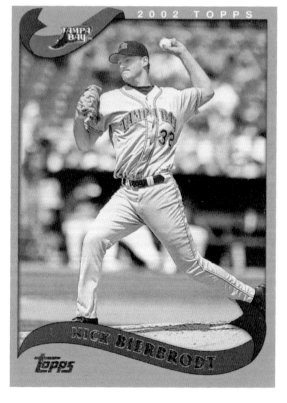

NICK BIERBRODT. A first-round pick by the Arizona Diamondbacks in 1996, Bierbrodt pitched for four teams in three seasons, including the Arizona Diamondbacks, Tampa Bay Devil Rays, Cleveland Indians, and Texas Rangers. In 38 games, the former Millikan High School star pitched 156 innings and had a lifetime 6.66 ERA.

MIKE GALLO. Gallo was named the 1999 Big West Conference Pitcher of the Year with a 10–3 record and a 2.45 ERA. Drafted by the Houston Astros in the fifth round of the 1999 amateur draft, the Millikan High School graduate played with them for four seasons. He threw 5.3 post-season innings with a 1.69 ERA and appeared in 160 career games for the Astros with a lifetime 4.11 ERA.

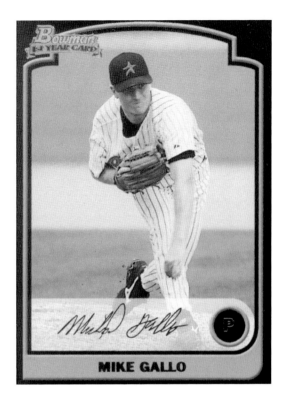

MIKE GALLO

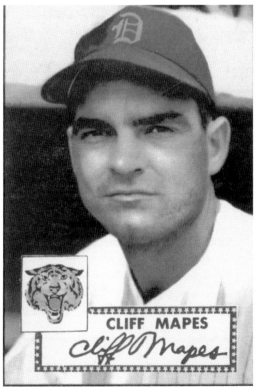

CLIFF MAPES

CLIFF MAPES. Mapes was taken from the Cleveland Indians by the New York Yankees in the 1946 Rule 5 draft. From 1948 through 1951 he played for the New York Yankees before being purchased by the St. Louis Browns in 1951. In 1952, the former Jordan High School star was traded by the Browns to the Detroit Tigers. As a career outfielder, Mapes played more than five seasons with 1,193 at bats, 289 hits, 172 RBIs, and had a lifetime .242 batting average.

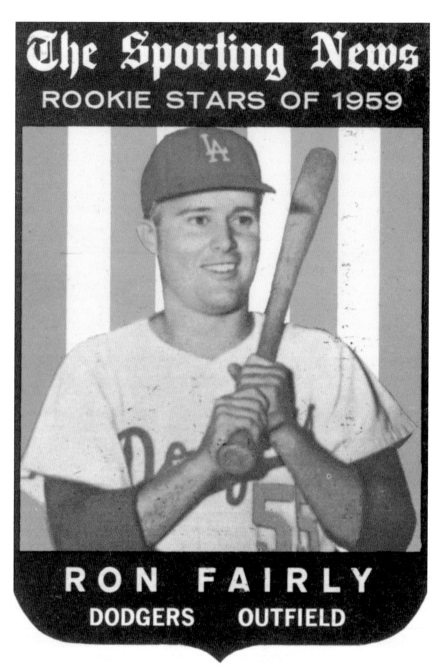

The Sporting News
ROOKIE STARS OF 1959

RON FAIRLY
DODGERS OUTFIELD

RON FAIRLY. Signed by the Los Angeles Dodgers in 1958, Fairly played his first 12 seasons with the Dodgers at first base and in the outfield. Fairly went on to play for the Montreal Expos, St. Louis Cardinals, Oakland Athletics, Toronto Blue Jays, and California Angles during an amazing 21-season major-league career. He hit .300 across four separate World Series appearances in 20 games and was a two-time all-star in 1973 and 1977. He had 7,184 plate appearances, 1,913 hits, 1,044 RBIs, and had a lifetime .266 batting average. Fairly was also known as the pride of Jordan High School.

BILL WILSON. Over four seasons, starting in 1950, Wilson played for the Chicago White Sox, Philadelphia Athletics, and Kansas City Athletics. He collected 145 hits, 77 RBIs, and had a .222 batting average. In 1953 while playing at Memphis, a laundry company offered him $200 extra for every home run. He hit 14 for the season and earned an extra $2,800. Wilson was a Jordan High School product.

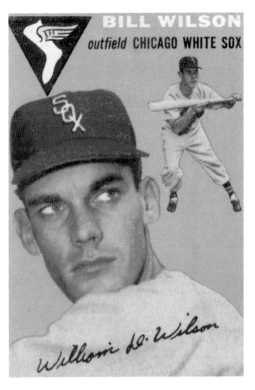

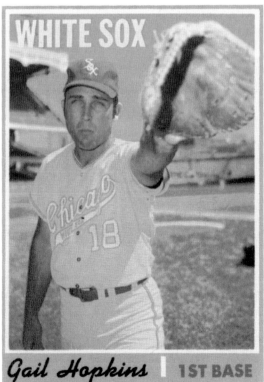

GAIL HOPKINS. Signed by the Chicago White Sox as a catcher in 1965, Hopkins played first base for three seasons with the White Sox, three with the Kansas City Royals, and one with the Los Angeles Dodgers from 1968 to 1974. He collected 324 hits, 145 RBIs, and finished with a career .266 average. He was a former Jordan High School player.

LEON HOOTEN
pitcher - Tucson
1975 P.C.L.

Tucson Toros

17

LEON HOOTEN. Hooten, a Jordan High School star, was drafted by the Oakland Athletics prior to the 1974 season and pitched 8.3 innings in the 1974 season at Oakland with a 3.24 ERA. He was later taken by the Toronto Blue Jays in the 1976 expansion draft.

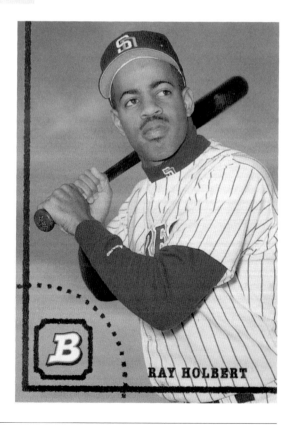

RAY HOLBERT

RAY HOLBERT. The older brother of Aaron Holbert, Ray Holbert signed with the San Diego Padres in 1988. In 1994 and 1995 the former Jordan High School mainstay played infield for the Padres, moving to the Atlanta Braves and Montreal Expos in 1998, and playing for the Kansas City Royals in 1999 and 2000. In five seasons he had 202 at bats with 45 hits, 11 RBIs, and had a .223 career average.

AARON HOLBERT. A first-round pick by the St. Louis Cardinals in the 1990 draft, Holbert made his debut on April 14, 1996, as an infielder with the Cardinals. He played with several clubs after the 1996 season and returned to play with the Cincinnati Reds in 2005. He was a Jordan High School graduate.

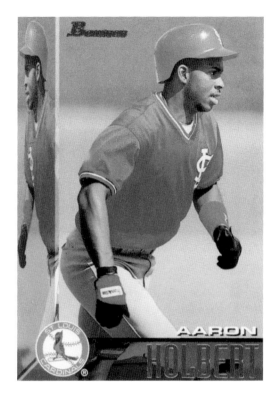

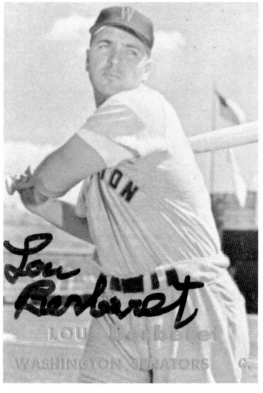

LOU BERBERET. Signed by the New York Yankees before the 1950 season, St. Anthony High School graduate Berberet was a catcher for the Yankees in 1954 and 1955 before joining the Washington Senators from 1956 to 1958. He finished the 1958 season with the Boston Red Sox and was traded to the Detroit Tigers for Herb Moford, playing for Detroit in 1959 and 1960. In seven seasons he collected 281 hits, 153 RBIs, and had a career a .230 average.

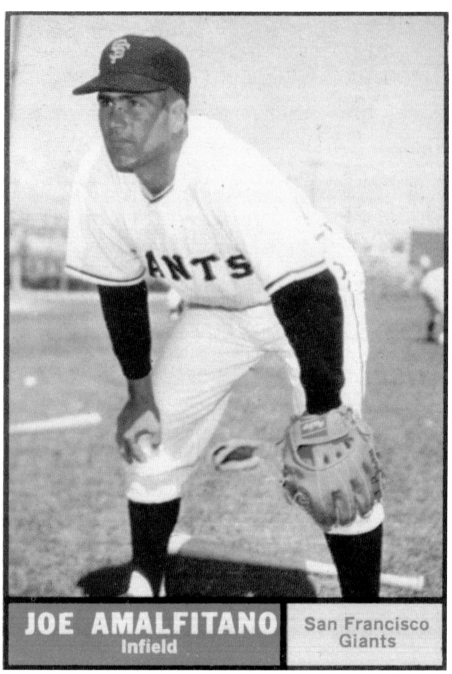

JOE AMALFITANO
Infield

San Francisco
Giants

JOEY AMALFITANO. The New York Giants took Amalfitano as a bonus baby (direct path to the major leagues) in the 1954 draft. The St. Anthony High School graduate played infield for the Giants in 1954 and 1955. From 1960 to 1967 he played with the San Francisco Giants, Houston Colt .45s, and Chicago Cubs. Known for clutch hitting and control in pressure situations, he was the sixth-youngest player in the National League in 1945 at the age of 20; Hank Aaron was the fourth youngest. In 10 seasons Amalfitano compiled a .244 average with 123 RBIs.

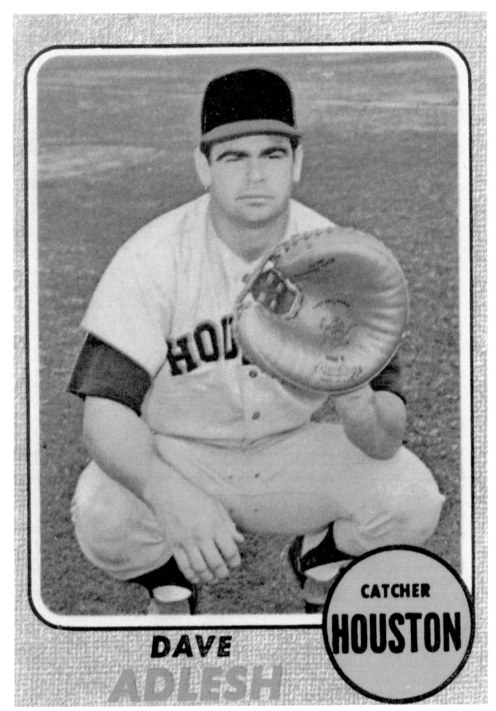

DAVE ADLESH. A former St. Anthony High School player, Adlesh was signed as a catcher by the Houston Colt .45s before the 1963 season. He played his entire major-league career with Houston, even after the team became the Astros in 1965. He appeared behind the plate for Houston in 156 games during six seasons with the club and was known for his throwing accuracy.

ACROSS AMERICA, PEOPLE ARE DISCOVERING SOMETHING WONDERFUL. *THEIR HERITAGE.*

Arcadia Publishing is the leading local history publisher in the United States. With more than 4,000 titles in print and hundreds of new titles released every year, Arcadia has extensive specialized experience chronicling the history of communities and celebrating America's hidden stories, bringing to life the people, places, and events from the past. To discover the history of other communities across the nation, please visit:

www.arcadiapublishing.com

Customized search tools allow you to find regional history books about the town where you grew up, the cities where your friends and family live, the town where your parents met, or even that retirement spot you've been dreaming about.